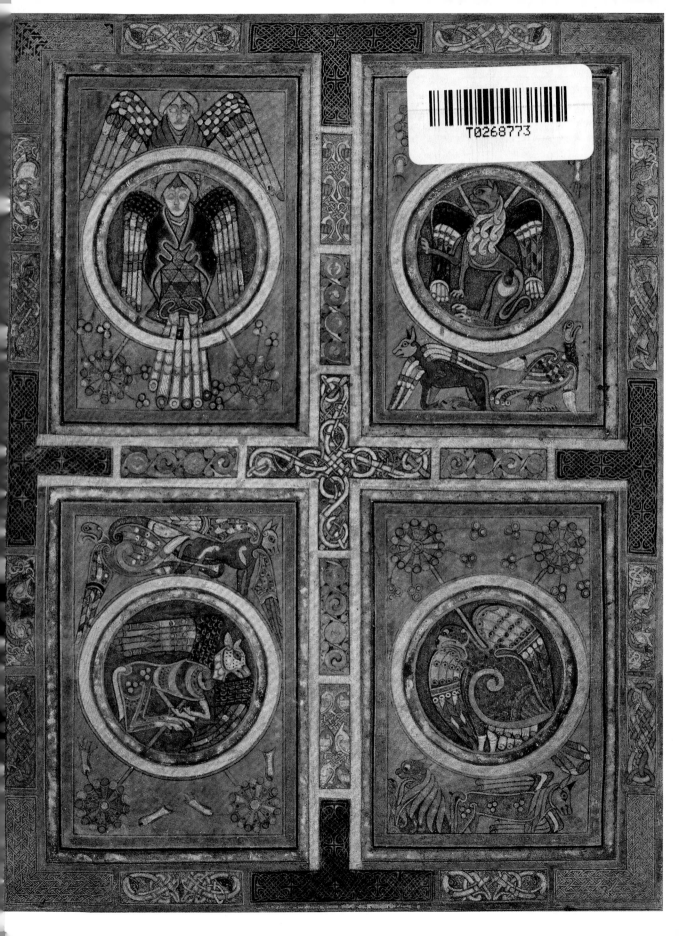

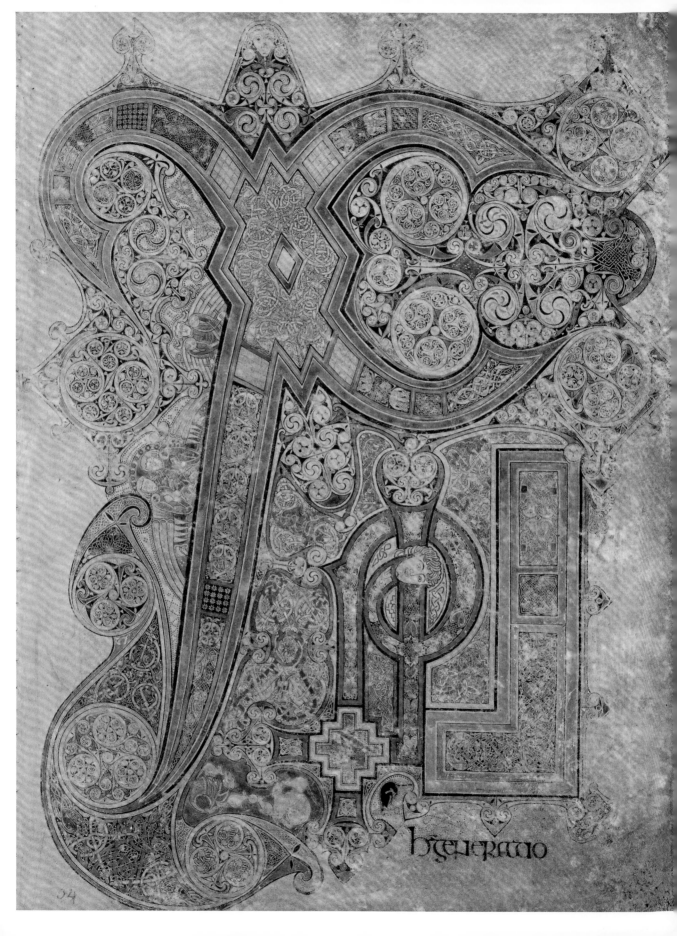

hgenerario

BERNARD MEEHAN

THE
BOOK
OF
KELLS

AN ILLUSTRATED INTRODUCTION
TO THE MANUSCRIPT IN
TRINITY COLLEGE DUBLIN

98 illustrations

For Andrew I and Margaret; Sarah, Lisa and Andrew II

Acknowledgments

In working on the Book of Kells over many years, I have benefited from the help and advice of many colleagues and friends, including: Josep Batlle, Susan Bioletti, Cormac Bourke, Claire Breay, Michael Brennan, Denis Brown, Mary Cahill, Denis Casey, Christina Duffy, Jaroslav Folda, Peter Fox, Derek Hull, Daniel P. Mc Carthy, Patrick McGurk, Jane Maxwell, Dáibhí Ó Cróinín, Raghnaill Ó Floinn, Felicity O'Mahony, Timothy O'Neill, Stuart Ó Seanoir, Daniele Pevarello, Heather Pulliam, Michael Ryan, Maeve Sikora, Roger Stalley, Robert Stevick and my colleagues in the Manuscripts & Archives Research Library at Trinity, past and present. I have also been greatly helped and encouraged by colleagues who have since sadly died: John Bannerman, Sean Freyne, Jennifer O'Reilly, Hilary Richardson and William O'Sullivan. My thanks are offered to them all.

First published in the United Kingdom in 1994 as *The Book of Kells: An Illustrated Introduction to the Manuscript in Trinity College Dublin* by Thames & Hudson Ltd, 181A High Holborn, London WC1V 7QX

First published in the United States of America in 1994 as *The Book of Kells: An Illustrated Introduction to the Manuscript in Trinity College Dublin* by Thames & Hudson Inc., 500 Fifth Avenue, New York, New York 10110

This fully revised and updated edition 2018
Reprinted 2023

The Book of Kells: Official Guide © 1994 and 2018 Thames & Hudson Ltd, London

Illustrations from The Book of Kells reproduced under licence from The Board of Trinity College, the University of Dublin

Designed by Peter Dawson gradedesign.com

British Library Cataloguing-in-Publication Data
A catalogue record for this book is available from the British Library

Library of Congress Control Number 2019947788

ISBN 978-0-500-48024-3

Printed and bound in China by C&C Offset Printing Co. Ltd

Front cover Detail from portrait of John. (f. 291v)

Half-title page The Evangelist symbols preceding Mark's Gospel are, clockwise from top left, the man (Matthew), the lion (Mark), the eagle (John), and the calf (Luke), arranged around a yellow-edged cross with snakes at its centre. (f. 129v)

Frontispiece The *Chi Rho* page. The first naming of Christ occurs here, at Matthew 1.18, ending the account of Christ's genealogy: *XPI* [Christi] *autem generatio* ('Now the generation of Christ'). (f. 34R)

pp. 6–7 Display lettering at the beginning of the *Breves causae* of Mark: *ET ERAT IO/HANNIS BAPTIZANS IHM ET UE/nit super eum* ('And there was John, baptising Jesus'). (f. 13r)

CONTENTS

audiem. Incipit

Sci

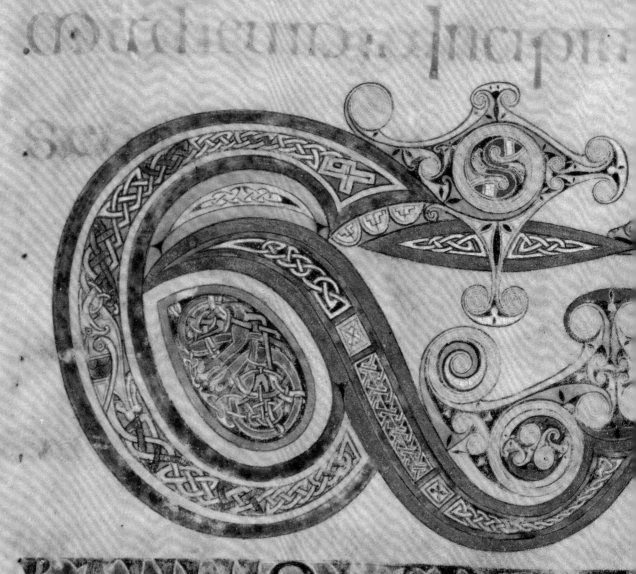

HANNISHABUZ

hit supereum sps oi

iosds urasd ait

temptauus :. Gposu

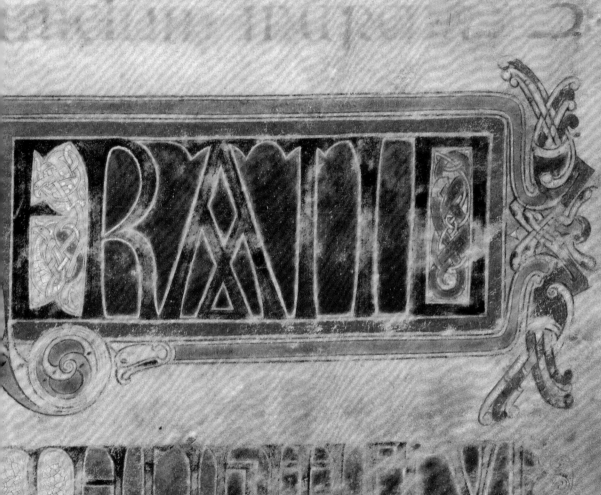

ERAT

et occident eum et occisus tertia die re
surga et illi ignorabant uerbum et
timebant eum interrogare ·:

Uenerunt capharnaum qui cum
domiessent interrogabat eos
quid inuia tractabatis ——— ·:

Illi tacebant siquidem interse
inuia disputauerunt quisessa
illorum maior et residens uocauit
duodecim et ait illis siquisuult primus
esse ericomnium nouissimus et omni
um minister et accipiens puerum sta
tuit eum inmedio eorum quem cum
complexusest se et ait illis quisquis
unum exhuius modi pueris innomin
meo recaperit merecipit ·:

Quicumque me susciperit

Opposite At Mark 9.30–36, Jesus foretells his death and resurrection. (f. 158v)

Below The beginning of Luke 4.1: *IESUS / AUTEM / PLENUS / SPIRITU / SANCTO* ('And Jesus being full of the Holy Ghost'). The words were written out at the foot of the page in the 16th century by Gerald Plunket of Dublin. (f. 203r)

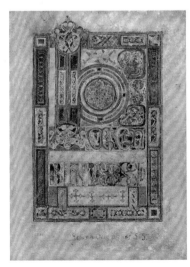

The Book of Kells can be seen as an inspiring symbol of Irish creativity and national pride. All other medieval manuscripts are in the shadow of its enigmatic imagery, vivid colouring and expressive intensity. It combines pages of ornament with the transcription of the Gospels to provide visual elucidation for an audience which expected to find colour and splendour in a church. Yet it is a sprawling and uneven piece of work, assembled by scribes and artists of varying abilities. It was not made in a single phase of activity. Certain pages and details, and the work of some of its artists, are highly refined and skilled, and can be appreciated readily. The eye is caught by the intricacy of the eight-circle cross page [p. 18] or the calligraphic verve of the word *Et* on f. 158v, where the snake that forms the bar of the *t* flows effortlessly into the form of a cross [opposite]. But other pages and details are not exceptional in their execution. Sections of f. 203r [below], which appear somewhat improvised in their layout and colouring, fall into that category, while the artist of f. 183r seems to have splashed paint on top of his decoration. Such contrasts help to make the Book of Kells a fascinating and almost inexhaustible subject of study.

The Welsh historian Giraldus Cambrensis (Gerald of Wales) composed a remarkable description of a manuscript clearly similar to the Book of Kells that he saw at St Brigid's church in Kildare in 1185:

> Among all the miracles of Kildare nothing seems to me more miraculous than that wonderful book which they say was written at the dictation of an angel … This book contains the concordance of the four gospels according to Saint Jerome, with almost as many drawings as pages, and all of them in marvellous colours … If you look at them carelessly and casually and not too closely, you may judge them to be mere daubs rather than careful compositions … if you … penetrate with your eyes to the secrets of the artistry, you will notice such intricacies … that you will not hesitate to declare that all these things must have been the result of the work, not of men, but of angels.[1]

EARLY HISTORY OF THE BOOK OF KELLS

Christianity probably first came to Ireland late in the 4th century. Patrick, a Briton brought as a captive to Ireland at the age of sixteen, became celebrated as the apostle of the Irish and founder of the church of Armagh late in the 5th century. In 521 or 522 Colum Cille, 'the Dove of the Church', was born into the ruling dynasty of present-day Donegal. Around 561 he travelled to Dál Riata in Scotland, and in 563 he settled on Iona, a fertile island off Mull. The community there grew to be the prosperous head of a confederation of monastic houses exercising wide

influence over ecclesiastical affairs in Ireland and in the north of England, where Lindisfarne became its most prominent foundation. The Irish Church differed from the Roman Church in its calculation of the date of Easter, in the shape of its ecclesiastical tonsure (the monks' hairstyle), and in its organization under abbots rather than bishops. These differences were resolved in favour of Rome, at least for the north of England, at the Synod of Whitby in 664.

Iona was attacked by Vikings in 795, in 802, and in 806, when sixty-eight of the community were killed. The next year, a section of those who survived moved to Kells in Co. Meath, the Annals of Ulster describing it as 'the new foundation of Colum Cille', while a monastic community remained on Iona. By 814 a church had been completed at Kells.

Relics of Colum Cille, possibly including manuscripts, were sent from Kells to Iona in 829, returning two years later. The earliest reference to the Book of Kells, as the 'great Gospel of Colum Cille', is recorded in 1007, when the Annals of Ulster note its theft from the western sacristy of the great stone church of Kells and its recovery 'after two months and twenty nights'. It is likely that its binding, and leaves at front and back, were lost during this episode. In 1090 'the two Gospels', presumably the Book of Kells and the Book of Durrow (c. 700; Trinity College Dublin, MS 57), were brought from Donegal to Kells, along with 'the bell of the kings', Colum Cille's *flabellum* (a liturgical fan used to protect the eucharist and its vessels from impurities), and 'seven score ounces of silver'.[2]

Was the manuscript written at Kells or on Iona, or partly at each location? And when? There is no certainty on the issue, but to place its creation around the year 800 allows claims to be made for either monastery, or for both. It may, conjecturally, have been produced on Iona

Above At the bottom of the page the word *Et* is formed with great verve, and the snake making the bar of the *t* creates the form of the cross. (f. 158v)

before the first Norse raid in 795, or at Kells during a period of calm after the completion of the church in 814.

Discussion of the issue has tended to proceed from an assumption that the Book of Kells was conceived as a unitary object and that the concept held firm through periods of violence, urgent relocations and changes of scribe. The manuscript impresses, however, like many medieval artefacts, as a composite creation, produced without overall coordination or collaboration by scribes and artists who worked at different times and may not necessarily have known each other.

The Book of Kells appears to owe its identity and its status to having been assembled, presumably at Kells, by a particular scribe, identified below as Scribe B (see p. 84). At the core of the compilation was John's Gospel, which had perhaps been brought from Iona. With its magnificent Evangelist portrait [p. 57], and its conservative style of script, this is the only Gospel text in the Book of Kells that was begun and completed by a single scribe, designated 'A' (see p. 82). It may originally have been devised to stand alone as a separate manuscript. The Irish Church had a great reverence for John, the Apostle especially loved by Jesus, and copies of his Gospel circulated as separate volumes.[3] It may be conjectured that elements were added to John's Gospel from the output of the same Scribe A: uncompleted preliminary texts (ff. 1, 8v–19v) and one quire of Mark's

Right The artist here appears to have splashed a drop of red pigment on top of the lowest left-hand purple lozenge. (f. 183r)

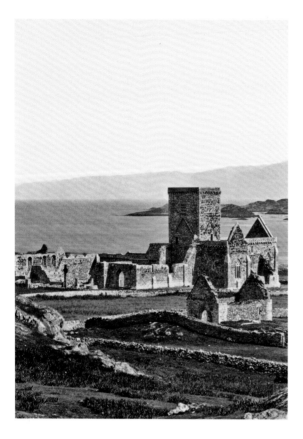

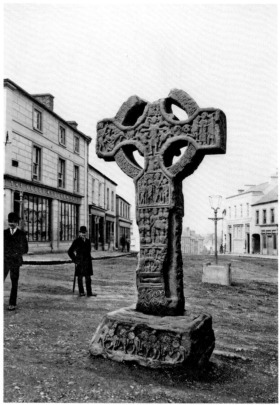

Gospel.[4] A full set of four Gospels was completed with quires prepared by two other scribes, C and D (see p. 87), for most of Matthew and Luke and the remainder of Mark, with pages of decoration which did not all integrate satisfactorily in relation to the text. Inserting f. 219 as a single leaf, presumably from a different manuscript, B realized that the text on its recto already appeared, with three additional words, on f. 218v. Those additional words were on f. 219v, so he excised the text on f. 218v [p. 84]. With the core texts assembled, Scribe B completed sections and supplied additions and numerous decorative details, in an attempt to provide coherence to a hitherto disparate collection of Gospel sections and images. This conjectural sequence may explain the uneven nature of the Book of Kells in the context of such historical circumstances as are known.

LATER HISTORY OF THE BOOK OF KELLS

In 1211 Kells was brought into the newly formed diocese of Meath, the monastic church functioning as the town's parish church. In the Irish rebellion against Protestant settlers in 1641 the town of Kells suffered serious damage, the church remaining in a state of ruin for more than forty years, fit only for the stabling of horses. With its safety endangered, the manuscript was sent to Dublin, probably in 1653, by the Governor of Kells, Charles Lambart, 1st Earl of Cavan. Henry Jones, as Bishop of Meath (1661–82), presented it to Trinity College.

Above left The monastery of Iona, before its restoration in the early 20th century.

Above The Market Cross at Kells, seen from the south in its former position in the market square, c. 1897. At its centre is the Biblical scene of Daniel in the lions' den.

Opposite The Library of Trinity College Dublin.

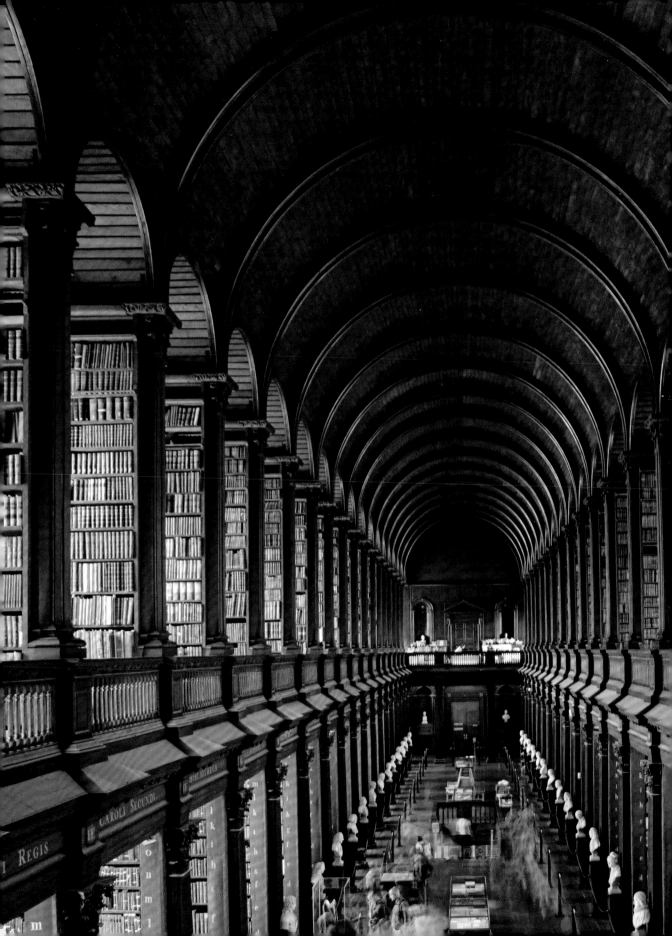

In 1742 the manuscript was rebound, partly as a result of the recovery of ff. 336/335, which returned to the book with heavy iron staining. The next rebinding, in early 1826, was the work of George Mullen, who received the sum of £22 15s. 'for repairing Columb Kills manuscript'. What Mullen saw as repair subsequent generations have deplored as vandalism, especially his trimming of the leaves. In 1895 the manuscript was rebound by Galwey of Eustace Street, Dublin. The present binding was carried out in 1953 by Roger Powell. The leaves were flattened through careful hydration and tensioning, and the book was divided into four volumes, one for each of the Gospels.

Charters in Irish were added to blank spaces on ff. 5v–7r and 27r in the 11th and 12th centuries. In the 15th century, a poem complaining about taxation on church land was added; it described the presence of the manuscript 'among the relics of the church, at the altars' (f. 289v). Gerald Plunket of Dublin inserted copious signatures and annotations in the 16th century, including disfiguring transcriptions of texts, on f. 203r for example [p. 9]. The signatures of Queen Victoria and Albert, and the date of their visit, 7 August 1849, were inscribed on flyleaves that had been added to the book in the 1826 rebinding.

Above Gerald Plunket notes chapter and verse in the margin of Luke 17.1. The initial *Et* was in place before the script, with the *b* of *inpo/sibile* interrupted.

Below A charter of November 1133, granting land to the monastic community of Kells, was added to the lower margin of one of the canon tables. (f. 6r)

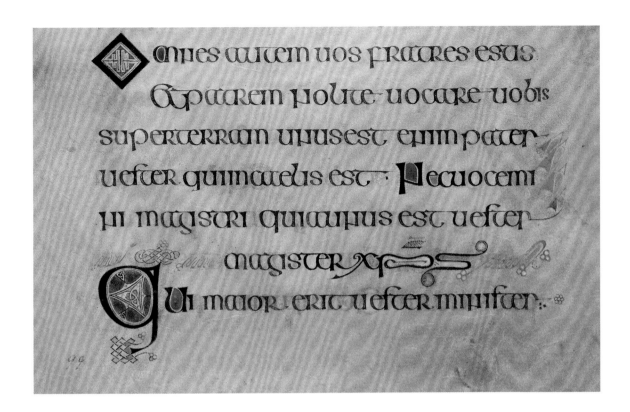

NAVIGATION OF THE BOOK OF KELLS

Above At Matthew 23.8–11, Jesus attacks the Scribes and Pharisees, declaring that 'only Christ is your master'. The abbreviation for *Christus* (*xps*) is emphasized on the second last line. (f. 99r)

Overleaf Conclusion of canon I: the Evangelist symbols under the top arch demonstrate their unity, the lion appearing to lick the face of the man, while the wings of calf and lion form a cross. In the outer arch, vines spring from an upturned blue chalice. (f. 2r)

SPELLING

The medieval Latin of the Book of Kells does not have the letters *j*, *v* and *k*. Spellings are erratic. Letters are often interchanged: *y* and *i*, *ae* and *e*, *m* and *n*, *b* and *p*. Insular manuscripts commonly provided double consonants in spelling; *ss* for *s* is especially prevalent, and on f. 277v there is a double *t* in *tettigisset* ('[when] he had touched [his ear]'; Luke 22.51). In the extracts from the manuscript that follow, *ihs* (Jesus) and its grammatical cases are expanded throughout to *iesus* and its grammatical cases; likewise *dns* (lord) to *dominus*; *xps* (Christ) to *christus*; *ds* (God) to *deus*; *sps* (spirit) to *spiritus*; and *scs* (saint) to *sanctus*.

CITATIONS OF PAGES

References to 'f.' and 'ff.' are to folio(s), otherwise known as a leaf or leaves. The recto (front) and verso (back) of a folio are referred to as 'r' and 'v'.

TRANSLATION OF THE GOSPELS

English translations and vocabulary of the Gospel texts are from the Douay version, a translation initiated by English Catholics in the 16th century, from the Latin Vulgate of Jerome: *The New Testament: Douay Version*, intro. by Laurence Bright (London 1977).

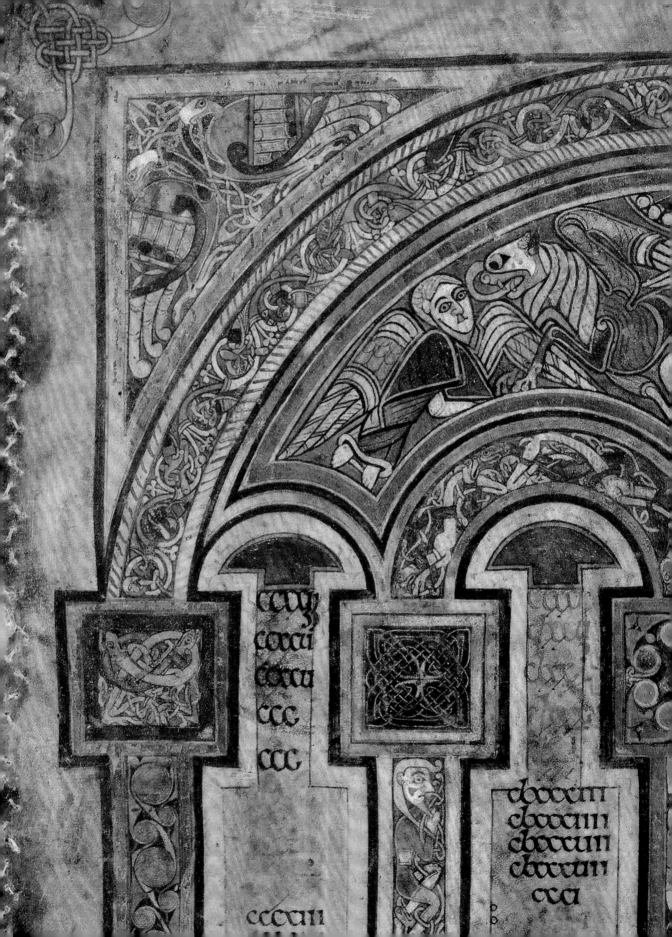

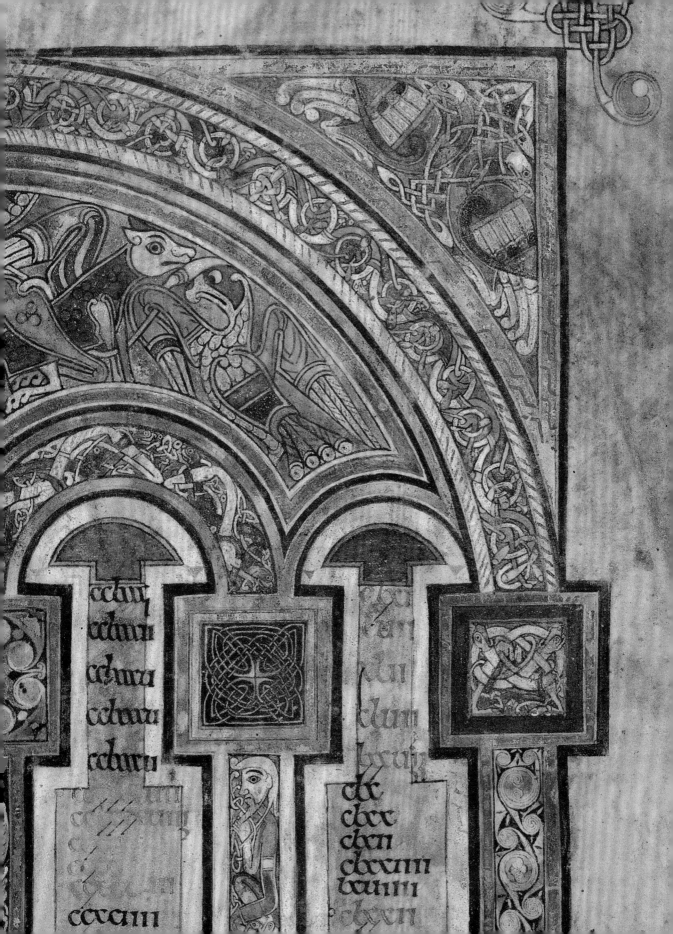

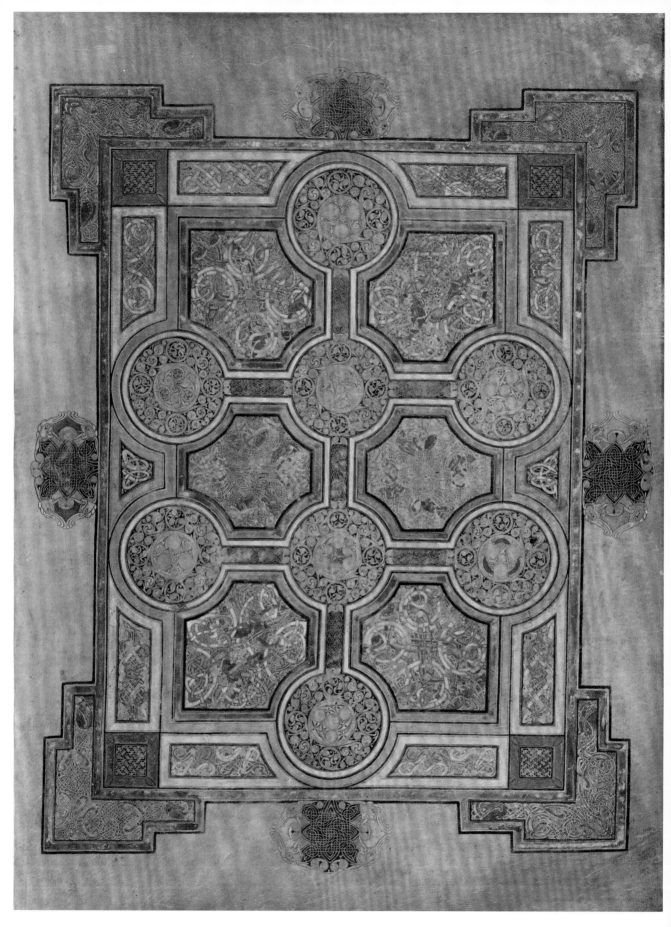

STRUCTURE OF
THE BOOK OF KELLS

Opposite A double-armed cross with eight circles, referring to the eight days of Christ's Passion (see also p. 44). It contains minutely executed interlacings of stylized lions (mostly in red), snakes (yellow) and peacocks (purple). (f. 33r)

The Book of Kells contains the four Gospels (by the Evangelists Matthew, Mark, Luke and John). The Gospels recount the life, death and resurrection of Jesus Christ. Mark's Gospel (*c.* AD 70) is widely regarded as the first written account, with Matthew and Luke (*c.* AD 80–85) adding supplementary material. These three accounts are known as the Synoptic Gospels. John's Gospel (*c.* AD 95–100) differs from them in content and approach. Viewed through long tradition as the work of the Apostle John, on whose account it was based (John 21.24), it is now held to be a composite work. The Gospel texts in Kells are from an 'Irish family' of the Vulgate, commissioned by Damasus (Pope 366–384) from Jerome (*c.* 347–420), and compiled by Jerome after study of Hebrew, Greek and Latin texts.[5] Preliminary texts are grouped together at the beginning.

The manuscript currently contains 340 leaves. In 1588 an unidentified hand counted that 'The boke contaynes tow hondreds V score and III leves at this present xxvii August 1588' (f. 334v). In that system, 'one hundred' was six score (6 × 20), or 120, making the total 343 leaves at that time. James Ussher, while Bishop Elect of Meath, checked the count: 'August 24 1621 I reckoned the leaves of this booke, and found them to be in number, 344. / he who reckoned before me counted six score to the hundred, and [*sic*]'.

The present numbering of the leaves, on the lower left corner of each recto, was carried out by James Henthorn Todd, College Librarian from 1852 to 1869. By error, he used 36 twice; the second was amended to 36*.

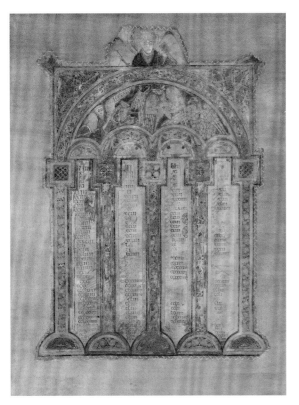 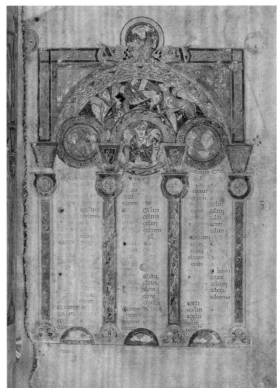

CANON TABLES

Canons, or concordances of Gospel passages that are common to two or more of the Evangelists, drawn up by Eusebius of Caesarea (*c.* 260–*c.* 340), are on ff. 1v–6r. The concordances allowed the reader, at least in theory, to navigate from one Gospel to another. Canons I–VIII are arranged in tables under architectural arches that provided a setting for varied and extravagant decoration following the thematic preoccupations of the manuscript [above and opposite]. Canons IX–X are placed in grids, in a marked change in design and colour scheme, probably executed by a scribe working later than the others [p. 14].

Above left Canon I lists, under arches, the passages that occur in all four Gospels. The first surviving leaf of the manuscript, it was damaged and is inset into new vellum. (f. 1v)

Above right The second page of canon II, noting passages that occur in the Gospels of Matthew, Mark and Luke. A sprouting chalice is placed above the arch, with peacocks, as symbols of Christ, gripping the tongues of lions, in a reflection of the image of Christ between two lions on the facing f. 2v (p. 58). (f. 3r)

Opposite Canons VI (Matthew and Mark), VII (Matthew and John), and VIII (Luke and Mark) are dominated by the winged symbols of the man (Matthew) and the eagle (John), their feathers drawn in extraordinary detail. As in the earlier pages, canon numbers and rubrics were added by Scribe B. (f. 5r)

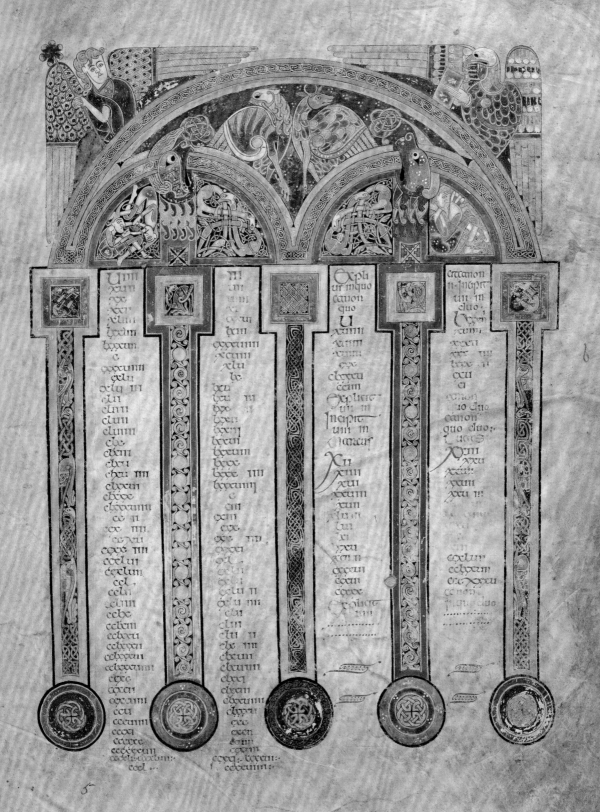

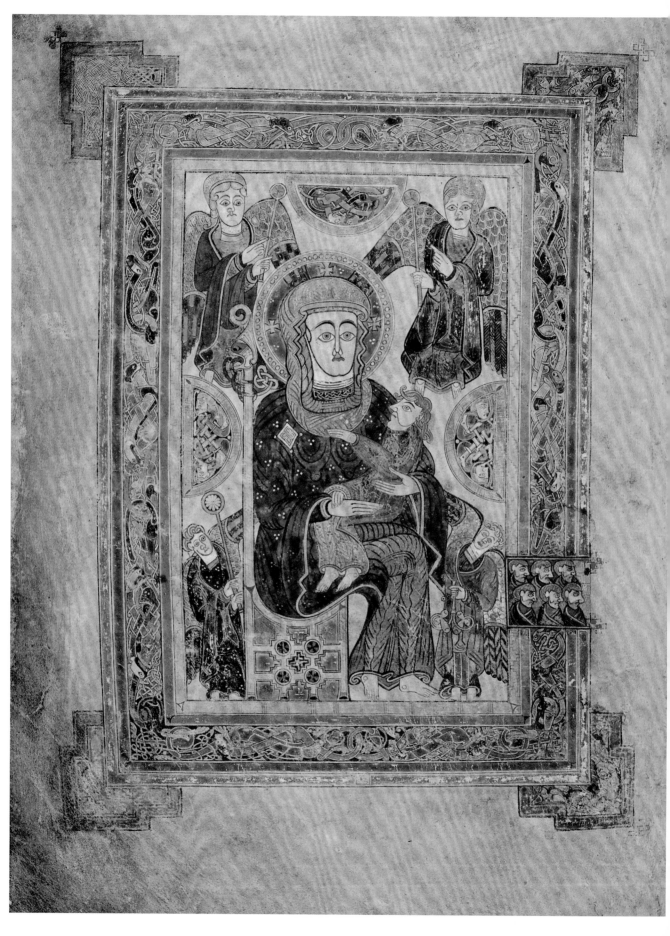

VIRGIN AND CHILD

Opposite The Virgin, seated on a throne and holding the child Jesus on her knee, is surrounded by archangels. A lozenge-shaped brooch is attached to her cloak. (f. 7v)

The Virgin, enthroned with the Christ Child on her knee, is surrounded by the archangels Michael, Gabriel, Raphael, and Uriel. Three of them hold a flabellum, while the fourth has a flowering rod, perhaps representing a liturgical sprinkler.[6] The base of her throne is decorated with crosses, and a lion's head on the back of the throne represents Christ. Her brooch is in the shape of a lozenge, also representing Christ, with another four lozenges inside it. Her mantle is coloured purple, the Roman imperial hue, and is decorated with triple dots, following a tradition from the East in which the motif was used for the finest garments.[7] Devotion to Mary was well founded in a Columban context: in the words of a hymn composed on Iona *c.* 700, 'She is the most high ... the holy venerable Virgin'.[8] The image, which may have become known in the Insular world through icons, is paralleled on the shaft of the St Oran's Cross on Iona, and on the late 7th-century coffin of St Cuthbert at Durham Cathedral. Six profile heads in the right border indicate that it should be read in conjunction with f. 8r opposite [p. 25].

HEBREW NAMES

Around ten leaves are missing at the beginning. The first surviving page (f. 1r) has suffered historic damage. It contains the final column of a defective and abbreviated etymological guide to Hebrew names in the Bible, compiled by Jerome *c.* 389. The entries run from *Sadoc* to *Zaccheus*, with their meanings provided in Latin. Introducing the canon tables that commence overleaf, the right column contains winged Evangelist symbols in groups of two: Matthew (man) and Mark (lion), then John (eagle) and Luke (calf). Each symbol holds a red book. The left hand of the man reaches across his body and holds the end of his braided hair, similar to the figure at the top of f. 8r. A similarly abbreviated list of Hebrew names in Luke is on ff. 26r–v.

BREVES CAUSAE AND *ARGUMENTA*

The *Breves causae* (lists of chapter contents) and *Argumenta* (prefaces that aim to characterize each Evangelist and discern the meaning behind his text) are assembled, for all four Gospels, on ff. 8r–25v.

The *Breves causae* are prosaic, summary texts, but the *Argumenta* were composed, late in the 4th century, in a Latin style that modern commentators have found difficult to comprehend, interpret or place theologically. John Chapman in 1908 described the texts as 'masterpieces of the art of concealing one's meaning',[9] and felt able to provide only 'attempts' at translation. Mark, for example, 'is said to have cut off his thumb after he had received the faith, in order that he might be counted unfit for the priesthood'.[10]

The opening of the *Breves causae* of Matthew on f. 8r [opposite] makes an emphatic, full-page statement of Christ's birth, opposite the image of the child Jesus on the knee of his Virgin mother [p. 22]. The *Argumentum* to Matthew's Gospel begins on f. 12r [above]. It is followed on f. 13r by the *Breves causae* of Mark. The *Argumentum* of Mark opens on f. 15v. The order of texts is then altered, with Luke's *Argumentum* on f. 16v, followed by John's *Argumentum*, beginning on f. 18r. Luke's *Breves causae* are on ff. 19v–23v, while John's *Breves causae* follow on ff. 24r–25v. All but the first and last texts are given distinctive ornamental openings.

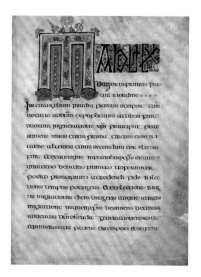

Above The opening words of the *Argumentum* of Matthew are displayed ornamentally: *MATHEUS EX IU/daeis sicut primus poni/tur in ordine* ('Matthew, who was of the Jews, even as he is placed first in order'). (f. 12r)

Opposite The *Breves causae* of Matthew open with a statement of the birth of Christ in Bethlehem of Judea. The page forms a complex, glorifying amalgam of script and decoration. (f. 8r)

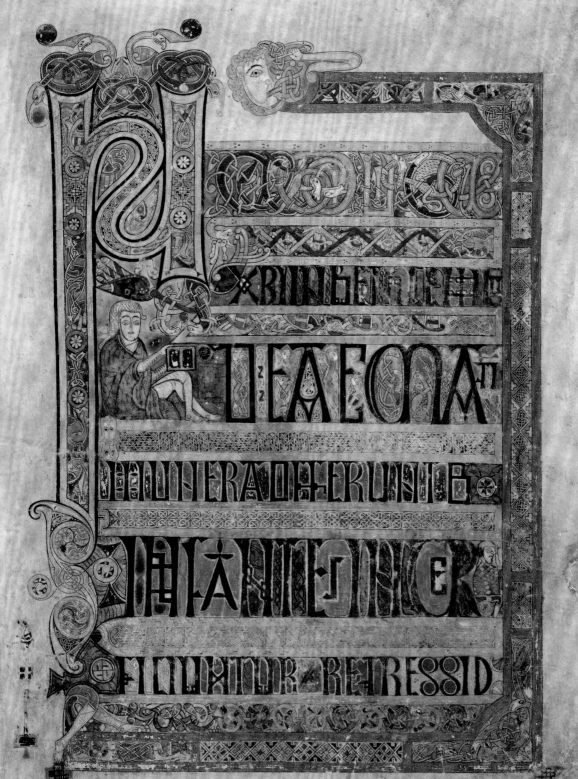

VENIENT
VEAEONAM
MUNERAOFFERUNT
INFANTESINTER
FICIUNTUR·RETRESSID

Nativitas xpi in bethlem luda . . . magi munera offerunt
et infantes inte . . . antur

8

MATTHEW'S GOSPEL

Matthew's Gospel opens with three decorated pages: symbols of the Evangelists around a cross on f. 27v [p. 54]; Matthew holding his Gospel on f. 28v [p. 56]; and the enlarged words *Liber generationis* ('The book of the generation'), opening his account of Jesus' life on f. 29r. Christ sits enthroned on f. 32v [opposite]. The 'eight-circle cross page' on f. 33r [p. 18] is a 'carpet' page wholly of decoration, depicting a double-armed cross with eight roundels embedded in a frame. The *Chi Rho* page is on f. 34r [p. 2], using the Greek monogram of the name of Christ (*Chi* and *Rho*) at the phrase *Christi autem generatio* ('Now the generation of Christ'; Matthew 1.18). The episode where Jesus prays on the Mount of Olives is illustrated on f. 114r [p. 71]. On its reverse, f. 114v [below left], emphasis is given to the words *TUNC DI/CIT ILLIS IHS OM/NES UOS SCAN[dalum]* ('Then Jesus said to them: All you shall be scan[dalized in me this night].'; Matthew 26.31). The words of the Crucifixion narrative stand on f. 124r [overleaf right]: *TUNC CRU/CIFIXERUNT / XPI [CHRISTI] CUM / EO DU/OS LA/TRONES* ('Then were crucified with him two thieves'; Matthew 27.38). An image of the Crucifixion may have been planned for the facing page.

Below left The page with Matthew 26.31 reads *TUNC DI/CIT ILLIS IHS OM/NES UOS SCAN[dalum]* … ('Then Jesus saith to them: All you shall be scan[dalized in me this night].') (f. 114v)

Below Jesus' ancestors are set out in two columns. Outlines of a frame and inset cross were drawn, but coloured only partially. (f. 30v)

Opposite Seated on a low-backed throne, Christ holds a red-covered Gospel book. His golden-haired head is flanked by peacocks, symbols of resurrection. (f. 32v)

Overleaf left Matthew 24.34–40, from the discourse on the Mount of Olives. (f. 105v)

Overleaf right Matthew 27.38: *TUNC CRU/CIFIXERUNT / XPI [CHRISTI] CUM / EO DU/OS LA/TRONES* ('Then were crucified with him two thieves'), the final words arranged in the form of a cross. (f. 124r)

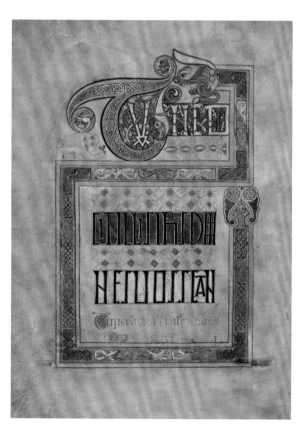

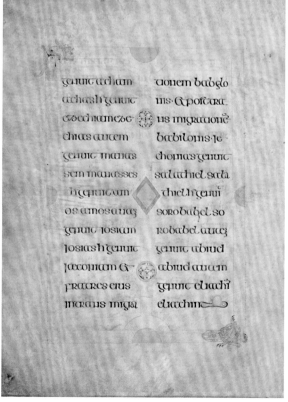

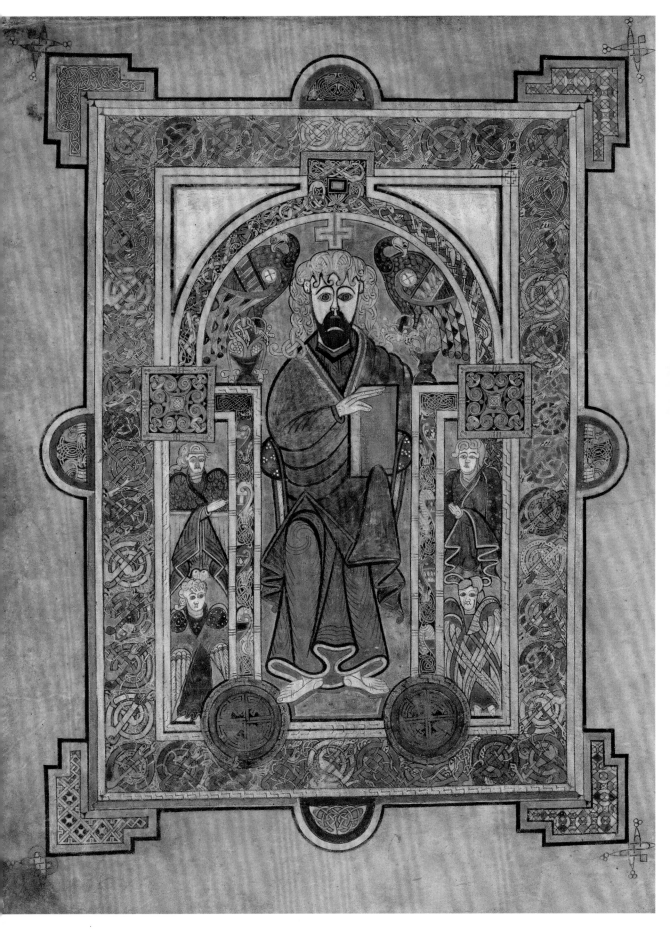

haec fiar· IT

Elum & terra & transibunt
uerba uero mea non prae
ribunt :· De die autem illa & ho
ra nemo sat neque angeli caelo
rum nisi pater solus

Sicut enim fuit in diebus noe
ita erit & aduentus filii
hominis sicut enim erant in dieb:
ante diluium comedentes & bi
bentes & nubentes & nupauim
tradentes usque ad eum in diem
quo intrauit noe in arcam & non
cognuerunt donec uenit diluiu
& tulit omnes ita erit & aduen
tus filii homin ·· IIS
Tunc duo erunt in agro unus

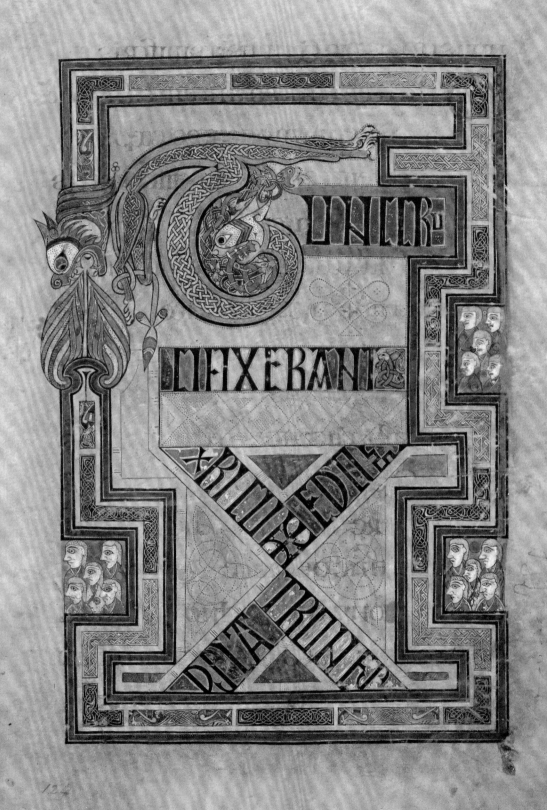

MARK'S GOSPEL

Mark's Gospel is prefaced with symbols of the Evangelists around a yellow-edged cross with interlaced snakes at its centre on f. 129v [below left and p. 1]. The opening words of the Gospel, *INIT/IUM EUANGE/LII IHU [IESU] / XPI [CHRISTI]* ('The beginning of the Gospel of Jesus Christ') are carried on f. 130r [opposite]. There, a figure at the top right wears a white garment decorated with interlace and dots. With his right hand he pulls his own beard; with his left he clutches the tongue of a lion biting his torso.

It is likely that a portrait of Mark would have faced the opening words of his Gospel. It was common scriptorium practice, in the interests of copying text at a faster rate, for pages of major decoration to be painted on single leaves, but such leaves were vulnerable to misplacement or loss when bindings broke down.

On f. 187v [below right], the concluding words of Mark's Gospel (16.19–20) are arranged in the upper and lower sections of a saltire cross, with a winged man and lion – the symbol of Mark – on either side, flanked by elongated lions.

Below left The Evangelist symbols preceding Mark's Gospel are, clockwise from top left, the man (Matthew), the lion (Mark), the eagle (John), and the calf (Luke), arranged around a yellow-edged cross. (f. 129v; see also p. 1)

Below The last page of Mark's Gospel. Two lions, symbol of Mark, stretch from top to bottom on either side of the page, one leg of each forming a saltire cross. On the right is the winged lion of Mark; on the left, 'the angel of the Lord'. (f. 187v)

Opposite The opening of Mark's Gospel: *INIT/IUM EUANGE/LII IHU [IESU] / XPI [CHRISTI]*. ('The beginning of the Gospel of Jesus Christ'). The first two letters are expanded, with interlacing snakes at their terminals. (f. 130r)

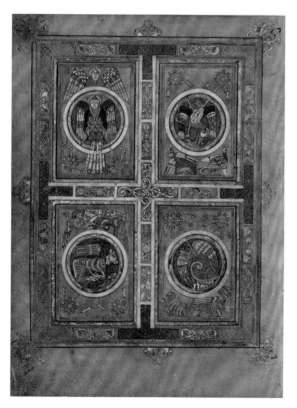

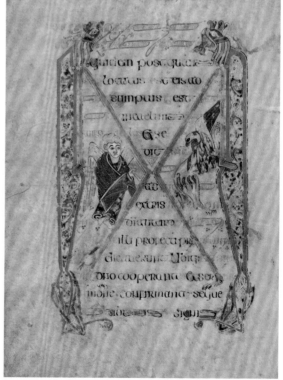

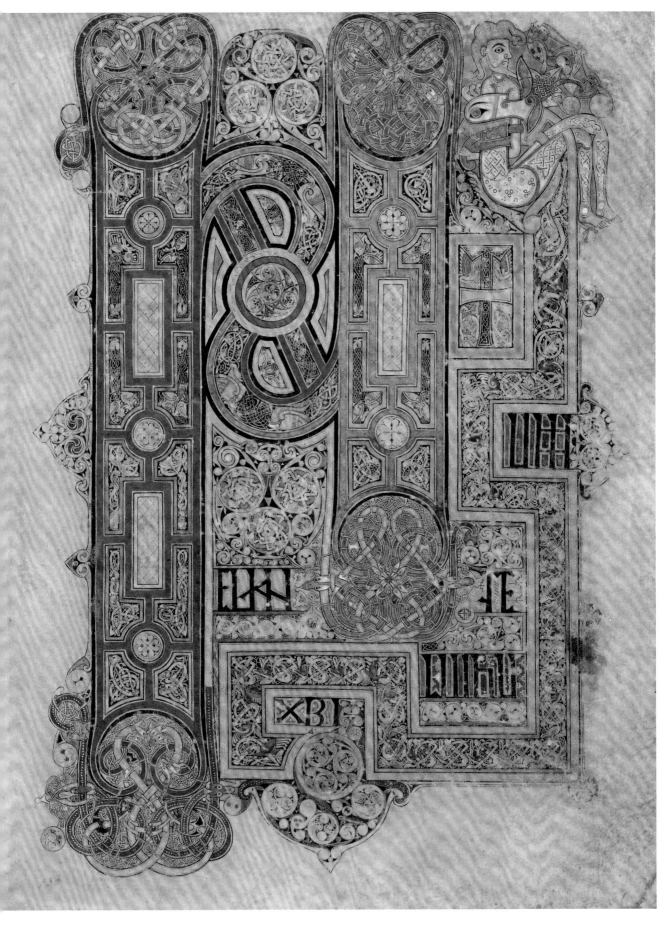

LUKE'S GOSPEL

The opening word of Luke's Gospel, *QUONIAM* ('Forasmuch as') on f. 188r is almost hidden in a thicket of decoration [opposite]. The letter *Q*, filled with trumpet spiral decoration, runs the length of the page, with *U* and *O* inside its bowl. The letters *N/IAM* are at the lower right of the page. Around them are twenty enigmatic figures. One pours wine into a goblet held by another; two place their heads within the mouths of lions, perhaps representing the mouth of Hell; and three hang as though on a cross. The genealogy of Jesus (Luke 3.22–38) is accorded lavish decorative treatment over several pages, ff. 200r–202r [below]. The Temptation of Jesus by the Devil (f. 202v) is a complex image [pp. 52, 70], facing the words *IESUS / AUTEM / PLENUS / SPIRITU / SANCTO* ('And Jesus being full of the Holy Ghost'; Luke 4.1) on f. 203r [p. 9]. On f. 285r the words *UNA / AUTEM SAB/BATI UALDE DELU[culo]* ('And on the first day of the week, very early in the morning'; Luke 24.1) begin the account of the women approaching the sepulchre [p. 53].

Below The genealogy of Jesus (Luke 3.32–38), from Naasson (top left) back to Adam and God (bottom right: see pp. 36–37). The word *Qui* runs down both pages in diverse forms. (ff. 201v–202r)

Opposite The opening word of Luke's Gospel, *QUONIAM* ('Forasmuch as'). (f. 188r)

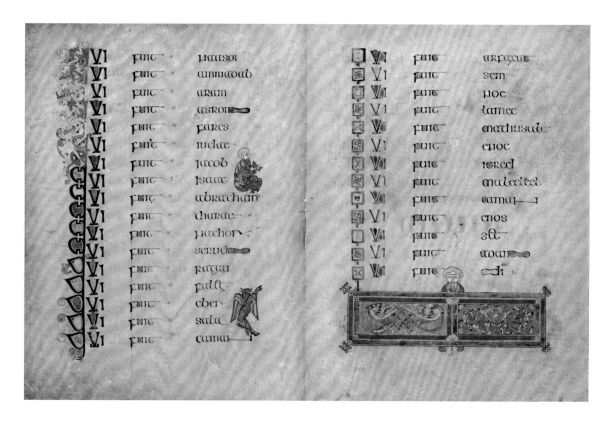

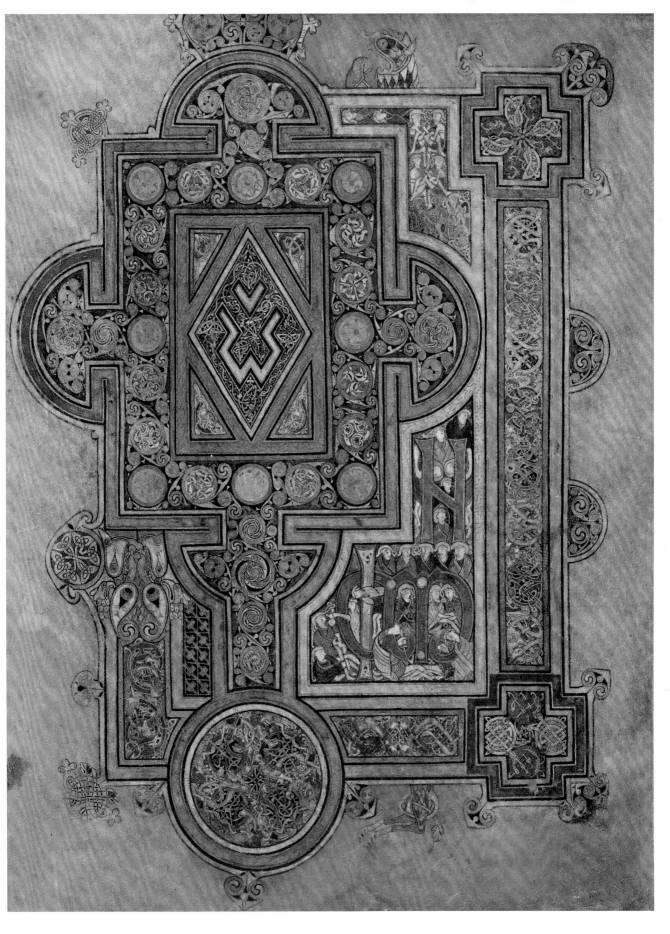

JOHN'S GOSPEL

John's Gospel lacks around twelve leaves from the end, probably torn away following the manuscript's theft in 1007 from the church at Kells. The surviving text ends on f. 339v, at John 17.13. The symbols of the four Evangelists are shown within a framed saltire cross on f. 290v [p. 55]. A powerful portrait of John, depicted as a scribe, is on f. 291v [p. 57]. Facing the portrait is the opening of John's Gospel on f. 292r [opposite]: *IN P/RINCI/PIO ERAT UER/BUM [ET] UER[B]UM* ('In the beginning was the Word, and the Word'). The letters *IN P*, filled with interlacing snakes, crosses and abstract ornament, dominate the composition. Snakes form the letters *RIN* and *C*, with *C* taking the form of a harp, played by the man who forms the letter *I*. The urge of the artist to decorate has taken precedence over legibility, to the extent that the letters *ET* and *B* are missing from the last line.

Below On the left-hand page the life-giving breath of two lions takes the form of eucharistic grapes. On the right-hand page, at John 6.53, the Jews ask, 'How can this man give us his flesh to eat?' (ff. 309v–310r)

Opposite The opening words of John's Gospel, *IN P/RINCI/PIO ERAT UER/BUM [ET] UER[B]UM* ('In the beginning was the Word, and the Word'), form one of the most splendid pages of the manuscript. (f. 292r)

Overleaf At the close of the genealogy of Jesus (see p. 32) a figure stands as though behind an altar, decorated with panels of peacocks and vines coming from a chalice. (f. 202r)

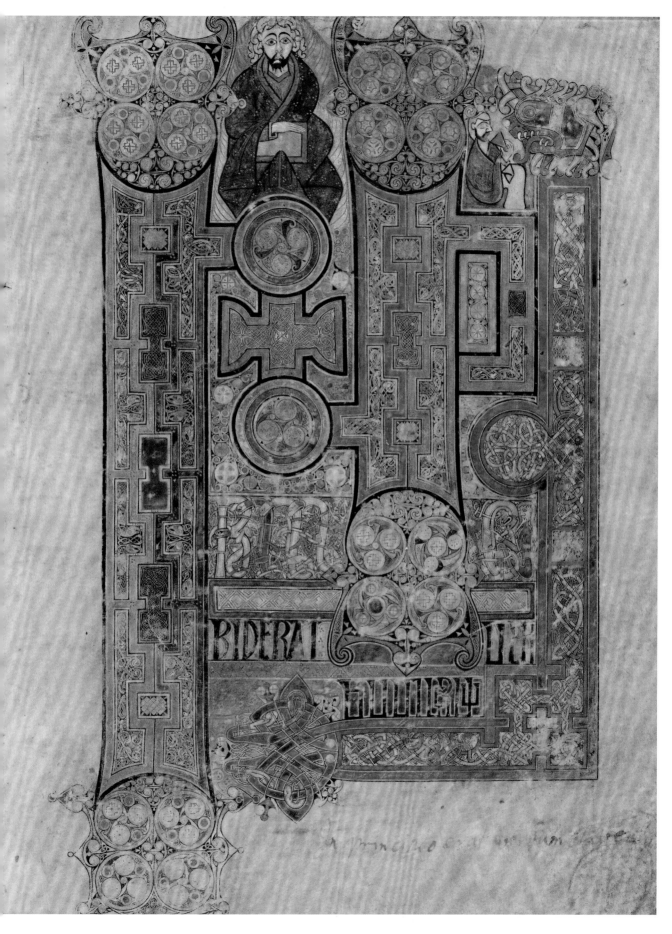

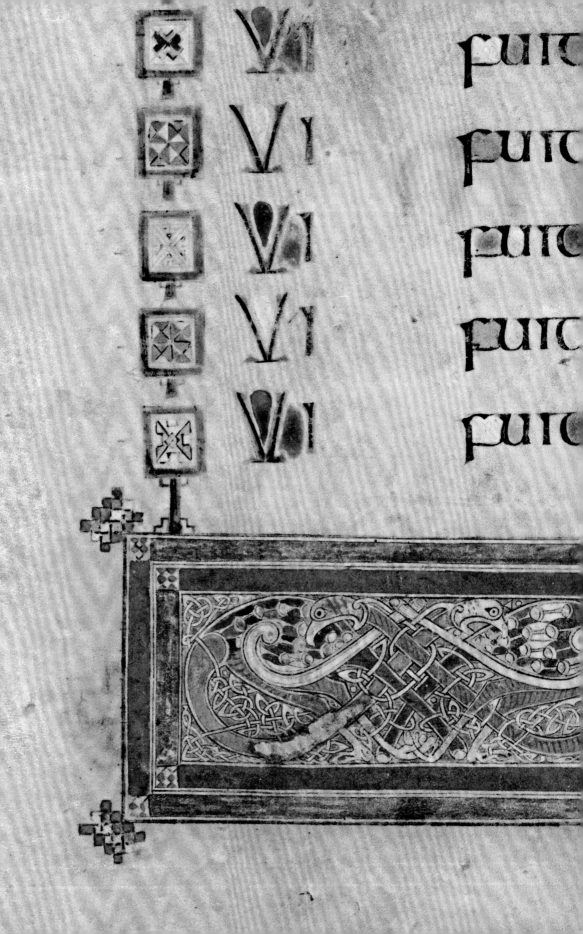

camui
enos
sct
cocum
di:

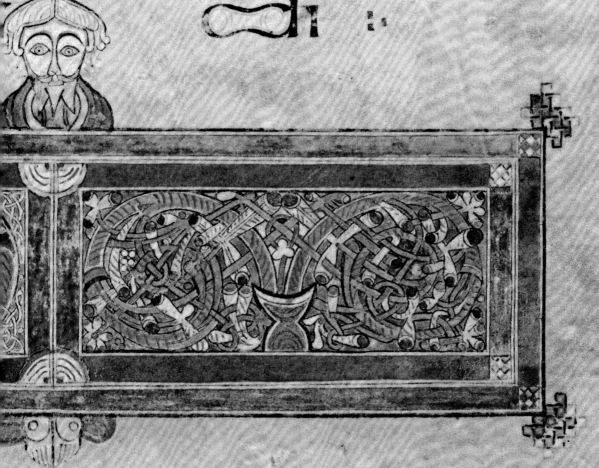

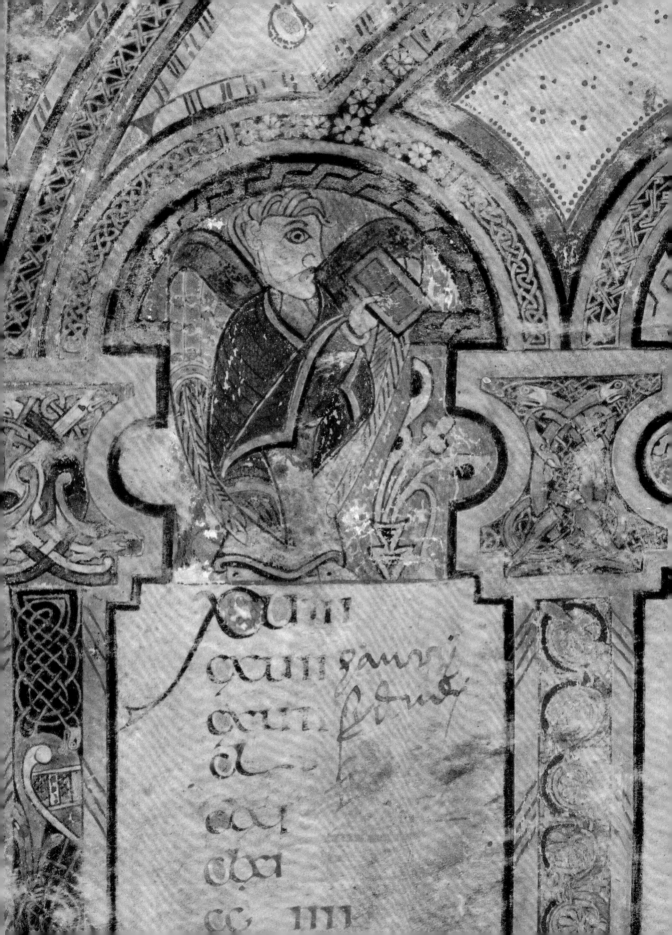

DECORATION OF THE BOOK OF KELLS

The decoration of the Book of Kells is dense and, in places, bewildering, but its themes are constant, forming a background rhythm to the text: Christ (his nature and his life, his suffering on the cross and his resurrection); the Eucharist as a path to eternal life; and the Evangelists. On many pages a Gospel book is depicted being held – by Christ himself, by angels, by the Evangelists and their symbols.

The text pages were designed with considerable sophistication. At Matthew 15.28, on f. 75r [p. 41], the last four lines are taken up with the final verse of the account of the woman from Canaan who pleads with Jesus to help her daughter, troubled by a devil: *Tunc respondens iesus ait ei / O mulier magna est fides tua fiat tibi / sicut uis et sanata est filia illius ex illa / hora* ('Then Jesus answering, said to her: O woman, great is thy faith; be it done to thee as thou wilt: and her daughter was cured from that hour'; Matthew 15.28). The text is enclosed and given focus by the head of a lion on the bar of the *T* of *Tunc* looking down to catch the eye of a lion at the end of the last line. The words of Jesus in lines 15–16 are marked out by diagonal red lines that function in the same way as modern quotation marks.

Opposite The man, symbol of Matthew, is placed at the top of the column referring to his Gospel in canon IV. He holds his Gospel book, and beside him is a flowering chalice. (f. 4r)

Right A lion's head in profile, with red tongue hanging out, at the top of the page where, in the sermon on the Mount of Olives, Jesus foretells his resurrection (Matthew 26.31). (f. 114v)

ANTECEDENTS AND INFLUENCES

The Book of Kells draws on a diverse decorative inheritance of abstract patterns and animal representations. The scale and range of its decoration have led commentators to find similarities in Anglo-Saxon, Pictish, Byzantine, Armenian and Carolingian art. To account for the formation of the Insular style, it must be supposed that jewellery, coins, textiles, icons and manuscripts had circulated in Ireland as imports, from the late Classical as well as the Early Christian world. Travel leads naturally to the movement of valued objects, and to the transfer and adaptation of motifs from one medium and place to another. The discovery that the cover of the late 8th century Faddan More Psalter was lined with papyrus provided physical confirmation of links, long suspected, with the eastern Mediterranean.[11] Influences from the Mediterranean run through the Book of Kells, assimilated and adapted by the artists.

The Book of Durrow (c. 700; Trinity College Dublin, MS 57), from Colum Cille's foundation of Durrow, Co. Offaly, is viewed as the earliest in the sequence of surviving fully decorated Insular Gospel manuscripts. Its preliminary texts resemble those in Kells, and the full-page cross on Kells f. 33r [p. 18] appears to be derived from the image on Durrow f. 1v. Ahead of the path followed by the Kells artists, Durrow's interlace is combined with motifs drawn from metalwork and trumpet spiral devices, which had native antecedents. Interlace first survives in an Insular context in Durham Cathedral Library, MS A.II.10 f. 3v, a fragmentary mid-7th-century Gospel book probably from Iona.

Red dots highlighting the shape of a letter, which are a striking feature of the Book of Kells, form the major decorative device of the 'Codex Usserianus Primus' (Trinity College Dublin, MS 55), a Gospel book conventionally dated to the early 7th century. Other graphic elements in the Book of Kells – trumpet spirals, the fish and the cross – formed the staple ornament of the Cathach, 'Battler' (Dublin, Royal Irish Academy, MS 12.R.33), a psalter of c. 600 traditionally attributed to the hand of Colum Cille himself. The Cathach employed 'diminuendo', by which letters at the beginning of a section of text are formed in diminishing sizes. The Book of Kells used this too, but restricted it to the first two letters of a word. Filling the shafts of initial letters with blocks of differing colours is a device of which the earliest examples in an Insular context are thought to be manuscripts in Durham Cathedral Library, MS A.II.10 f. 2r and in Milan, Biblioteca Ambrosiana, MS S.45.sup. p. 12, the latter an early 7th-century copy of Jerome's Commentary on the Book of Isaiah from the Irish foundation of Bobbio in north Italy.

Opposite Matthew 15.22–28 concerns a woman from Canaan who beseeches Jesus to cure her daughter, troubled by a devil. The woman's faith allows her daughter to be cured. (f. 75r)

filia mea male a demonio uexatur qui

nonrespondit ei uerbum & accedentes

discipuli eius rogabant eum dicentes

dimitte eam quia clamat post nos

Ipse autem respondens ait non su(m)

misus nisi ad oues quae perierunt

domus israhel

At illa uenit & adorauit eum dicen(s)

d(omi)ne adiuua me qui respondens

ait non est bonum sumere panem fili

orum & mittere canibus Et illa dix(it)

etiam d(omi)ne nam & catuli edunt de mi

cas quae cadunt de mensa dominorum

suorum Tunc respondens ih(esu)s ait ei

o mulier magna est fides tua fiat tibi

sicut uis & sanata est filia illius ex illa

oculis ihs dixit pater clarifica filium tuum

Pater sce seruteos Innomine tuo id est
discipulos · utdpilatum ·

Et duxerunt ihm adlannam Et caiafam

Et decruce dixit ihs discipulo quem di
ligebat ecce mater tua

Post resurrectionem apparuit ihs disci
pulis Et noncredebat thomas Et iterum ap
paruit ei increbat eum · thy ayse vith

Et cumdixo manifestra se ihs discipulis erat p tiro dicens
meus exregistre me

si hic est xps di electus

Iudebant autem ei Et milites

accedentes Et acetum offerente

illi dicentes situ es rex iudeoruz

saluum te fac

Erat autem Et super scriba oth

scripta super illum litteris

Opposite, above The first page of John's *Breves causae*, written by Scribe B. Three lines from the end of the page, minuscule script, resembling sections of the Book of Armagh, is used. (f. 25v)

Opposite, below The Passion in Luke's Gospel (23.34–39) is decorated intensively with bold initials on the left and cross forms on the right. Three lions compose the first two letters of *Inludebant* ('mocked him'). (f. 283r)

The 8th-century Barberini Gospels (Rome, Vatican Library, MS Barberini Lat. 570) resembles the Book of Kells in its indirect illustration of text: on f. 17v, for example, the phrase 'Consider the birds of the air' (Matthew 6.26) seems to be illustrated on the facing page by four birds eating grapes.[12] The 8th-century Lichfield Gospels (Lichfield Cathedral Library) applied pigments, as the Book of Kells did, in layers of different colours. The text of John's Gospel in the early 8th-century Durham Gospels (Durham Cathedral Library, MS A.II.17) seems to have been used as an exemplar in the Book of Kells.[13] The Macregol Gospels (Oxford, Bodleian Library, MS Auct. D.2.19), ambitiously conceived and lavishly coloured, has a colophon in the name of its master scribe, Macregol, Abbot of Birr, Co. Offaly. That he died in 822 offers an established end date for his work and a point of comparison for other manuscripts.

The Book of Armagh (Trinity College Dublin, MS 52), containing a complete New Testament along with texts relating to St Patrick, was produced in part by the scribe Ferdomnach for Torbach, who served as Abbot of Armagh in the year 807. There are strong resemblances between the style of his Evangelist symbols, executed in pen and ink, and those in the Book of Kells, and between the passages that he wrote in minuscule display script and the flourished final lines of some pages in Kells.

Such comparisons are drawn from a very small corpus of surviving Insular manuscripts, and discoveries of new material can effect considerable shifts in scholarly perceptions. Three tiny fragments of Luke's Gospel, retrieved from a book binding in Germany (Berlin, Geheimes Staatsarchiv Preussischer Kulturbesitz XXHA, Nr 84, 71, a,b,c), currently under investigation, bear a remarkable similarity to the script, though not especially to the decoration, of the Book of Kells.[14]

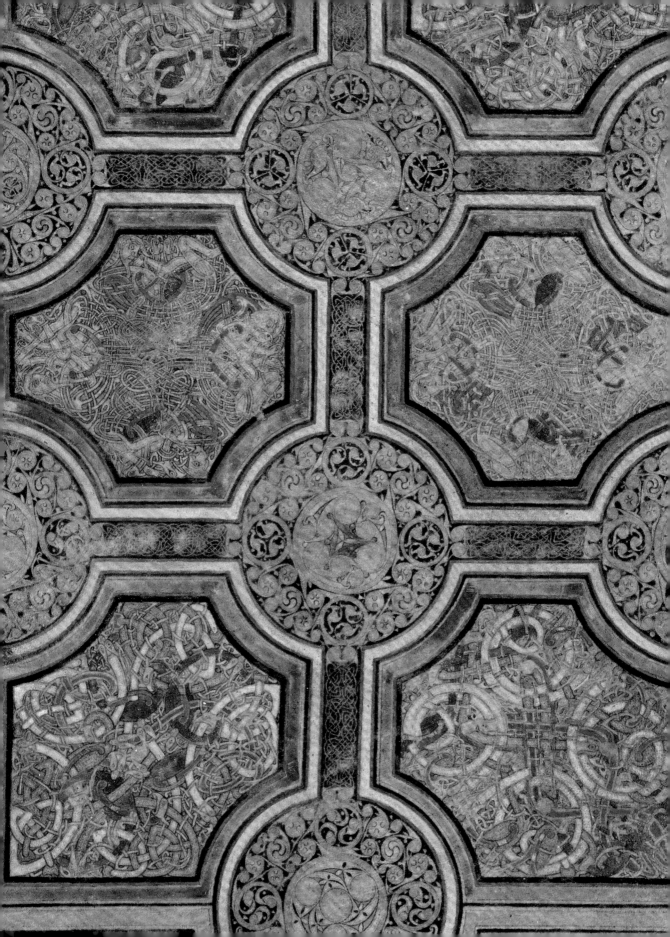

SYMBOLS AND THEMES

Opposite Detail of the eight-circle cross page (see p. 18). Red human figures interlace with peacocks and lions, forming what is perhaps the most complex decoration in the entire manuscript. (f. 33r)

Below At Mark 8.34 the bowl of *Et* encloses equal-armed crosses in green and white (flanked by triple dots), while the bar of the *t* takes the form of another cross. (f. 155r)

I. THE CROSS

The Columban poem *Altus prosator* proclaimed the cross as a sign of the Second Coming:

> When Christ, the most high Lord, comes down from the heavens,
> the brightest sign and standard of the Cross will shine forth.[15]

As an emblem of Christ's sacrifice and its redemptive function, the cross was central to the Christian faith, being a feature of Gospel manuscripts at least as early as the Coptic Glazier Codex of *c.* 500.[16]

The cross takes a large-scale form in the eight-circle cross page (f. 33r) [p. 18]. On other pages, close examination reveals much smaller examples of the motif. In the left section of the panel on the lower right of f. 34r, for example, the heads of peacocks meet at a foliate cross, drawn on a scale so minute that only those bending low over the book, in good light, could have gazed on it. Elaborate Greek crosses, strongly paralleled in metalwork, surround John's portrait on f. 291v [p. 57]. The Evangelist symbols on ff. 27v, 129v and 290v [pp. 54, 1, 55] are arranged around crosses. The text of Matthew 27.38, '[Then were crucified] with him two thieves', is arranged on f. 124r in the form of a cross. The Passion sequences of the Gospels are dominated by cross forms; on f. 283r (Luke 23.34–39) crosses in circles fill spaces at the ends of lines [p. 42].

For Augustine (354–430), the cross was 'the devil's mousetrap'.[17] Monastic enclosures and church boundaries were marked and protected by crosses: 'wherever you find the sign of the cross of Christ, you will do no harm', as the Irish canons commented.[18] This apotropaic or protective function was mirrored at Luke 4.1–7 (f. 203v): Jesus spends forty days in

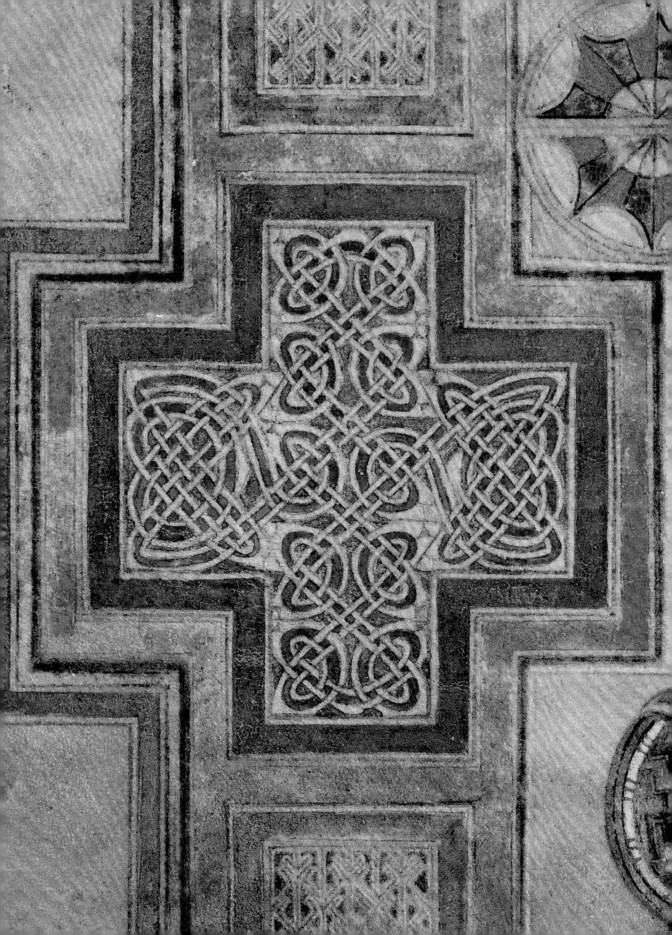

Opposite Equal-armed crosses, interlaced in a style that resembles metalwork, surround John on his portrait page (p. 57). This cross is on the left. (f. 291v)

Below An elaborately interlaced and coloured cross is set within a lozenge in the word *Et* at Luke 4.2, countering the temptation by the Devil. (f. 203v)

the desert, eats nothing, and is tempted by the Devil, who says, 'If thou be the Son of God, say to this stone that it be made bread.' The artist created an elaborate *Et* on line 4, in yellow, red, purple and two shades of blue, and with exceptionally close spirals; on the purple ground he placed a cross from interlace within a lozenge, as an indication that Jesus could draw on its power [p. 77].

On f. 179v, the letters *Su* of *Summus* at the beginning of Mark 14.63 ('the high priest, rending his garments …') are enlarged within a double rectangular frame, the letter *S* being formed twice, once as a yellow tendril entwined around the letter *u* (in green) and again in the red oval forms over which these letters are placed. Eight cross forms (in blue) emerge from the curves, representing the hill of Golgotha. At this time of Jesus' interrogation by the high priest, a visual allusion is being made both to his forthcoming Crucifixion and to his resurrection on the eighth day of the Passion.

Eight-leafed crosses resembling a marigold are on the *flabella* held by angels on either side of the Virgin (f. 7v) [p. 22]. A multi-leafed cross on the *flabellum* held aloft by the angel to the lower left is matched by six similar crosses defining the shape of the initial letter of *Natiuitas* on the facing page, f. 8r [p. 25]. These represent, fittingly, the star of Bethlehem, which guided the Magi to Jesus' birthplace (Matthew 2.1–10).

II. EUCHARIST

The institution of the Eucharist was recorded in the Gospels of Matthew, Mark and Luke. It forms the central ceremony of the Christian faith, in which, for many believers, the actual body and blood of Christ are consumed in the form of bread (communion hosts) and wine.

Eucharistic imagery is ubiquitous. Communion hosts are on ff. 34r and 48r [opposite and p. 69], and on the symbol of the calf on f. 27v [p. 54]. At the top border of *Una autem* (Luke 24.1) on f. 285r [below] a blue chalice, which must have stood out brightly when it was freshly painted, spills vines that multiply around the page, consumed by a triumphal parade of lions, two of them flanking the chalice and feeding on a trinity of grapes. To the lower right on f. 34r, a chalice is positioned upside down, with vines falling from it. In the arch above the canon tables on f. 2r, vines tumble in endless abundance from an upturned chalice [pp. 16–17]. A chalice placed horizontally on f. 292r throws out luxuriant vines among the letters *rin* of the opening words of John's Gospel [p. 35]. In the Lucan genealogies of Jesus, a cloaked, squatting figure holds up a chalice (f. 201v) [right]; his feet rest on the last letter of the name of Jesus' ancestor Abraham (*abracham*), making a connection between the faith Abraham showed in being prepared to sacrifice his son Isaac (Genesis 22.1–13) and Christ's sacrifice of his blood.

Flowering chalices are inserted at many line endings, presenting on some pages as expert, rapid and almost distracted sketches. At John 15.5, Jesus declares, 'I am the vine; you the branches' (*Ego sum uitis uos autem palmites*; f. 334v line 11), prompting the artist to fill the first letter with vigorous vine scrolls.

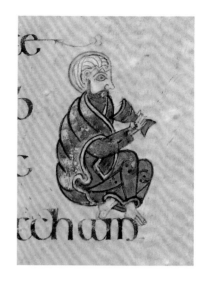

Above A figure holding a chalice is poised above the name of Abraham in the genealogy of Jesus. (f. 201v)

Below A small blue chalice is placed in the top border of the page where the account begins of the women approaching the sepulchre. (f. 285r)

Opposite In a small detail near the foot of the *Chi Rho* page (p. 4), two cats grasp the tails of two rodents that seem to be tugging at a communion host. (f. 34r)

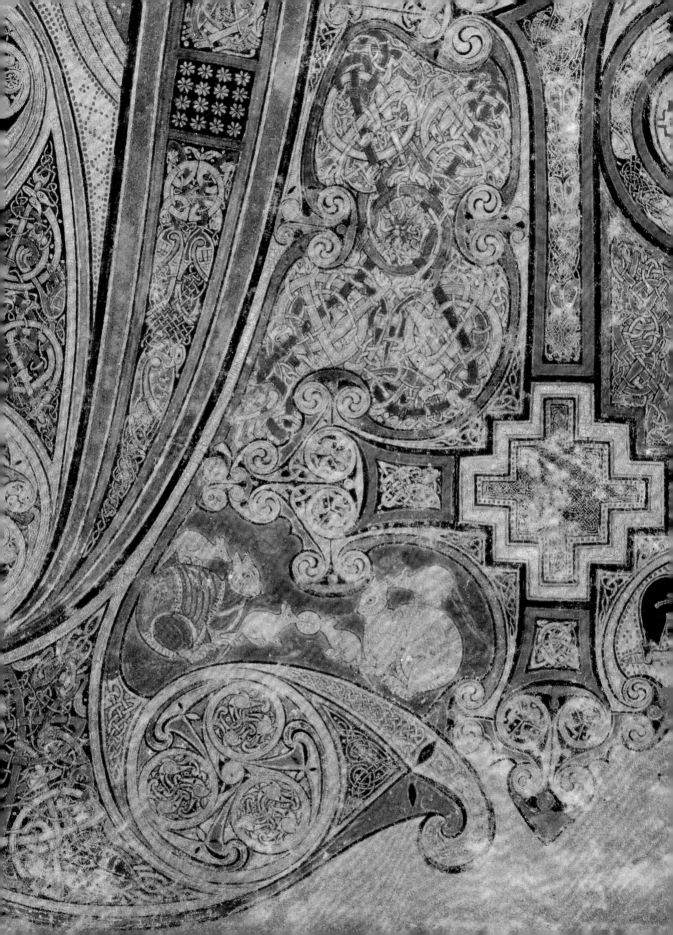

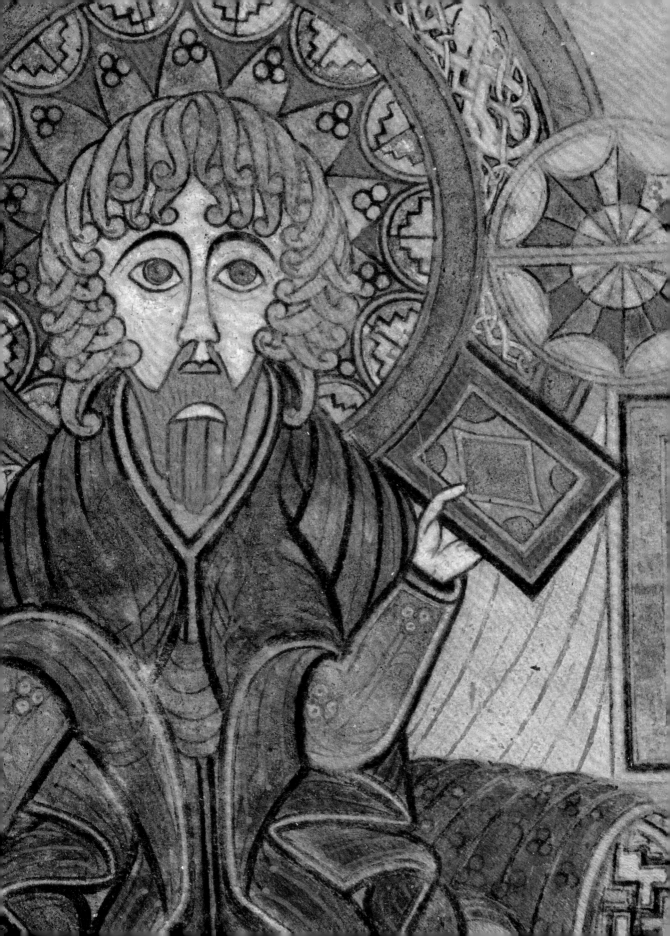

Opposite Detail of the portrait of John at the beginning of his Gospel (p. 57). In his left hand he holds a book decorated with a lozenge divided into a further four lozenges. (f. 291v)

Below left Lozenge forms, representing Christ, are prominent on the page as a response to the affectations of the Pharisees described in the text. (f. 99r)

Below right A sequence of lozenges within lozenges, symbolizing Christ, is at the centre of the page of Evangelist symbols preceding the opening of John's Gospel. (f. 290v)

III. LOZENGE

The lozenge represented Christ, the *logos* or Word of God, from Early Christian times. John's Gospel opens with the words, 'In the beginning was the Word, and the Word was with God, and the Word was God'. A lozenge, divided into four further lozenges, is the central decoration of the book held out by John [opposite]. With its four corners, it represented the early medieval understanding of the cosmos. The Apocalypse of John described 'four angels standing on the four corners of the earth, holding the four winds of the earth' (Rev. 7.1).

On f. 290v the Evangelist symbols are arranged around a lozenge that is at the centre of a saltire cross [below and p. 55]. On f. 34r, the *Chi Rho* page [p. 2], it is at the heart of the monogram of the name of Christ. The word *omnia* ('all') is imbued with the significance of the totality of the Word of God by the formation of its first letter in the shape of a lozenge, as on f. 48r.

Four lozenges could be formed readily into a cross, as at the top corners of the canon tables on f. 3r [p. 20]. The Virgin's brooch on f. 7v is in the shape of a lozenge, with another four lozenges inside it [p. 22]. Lozenges face each other, as the centres of what may be uncompleted crosses, at Christ's genealogy on ff. 30v–31r [p. 26].

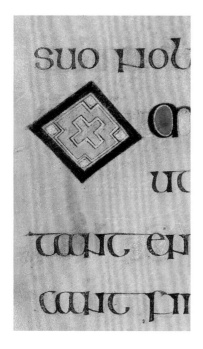

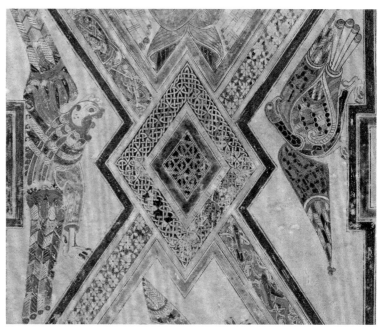

IV. ANGELS

After the fall of the 'bad angels', it was the angels 'who stood in their celestial vigour', as Isidore of Seville expressed it, who 'have charge of the outcomes of all endeavours'. They are always spirits, but become known as angels (the Greek word for messenger) when they are commissioned to 'announce the will of God to people', artists providing them with wings to signify the speed at which they work.[19] Sight of angels was afforded to none but the most worthy. Colum Cille was often to be seen in their company.[20] Christ is portrayed with angels on f. 32v [p. 27], and they accompany him at critical moments: with his Mother on f. 7v [p. 22]; facing the reference to his birth in the *Breves causae* of Matthew on f. 8r [p. 25]; at the first mention of his name on f. 34r [p. 2]; at his temptation by the Devil on f. 202v [below]; and at the beginning of the resurrection narrative on f. 285r [opposite]. Mostly, the angels are in gatherings of four, to be identified as the principal archangels – Michael, Gabriel (who, in Luke's Gospel, had announced to Mary the conception of Jesus), Raphael, and Uriel.

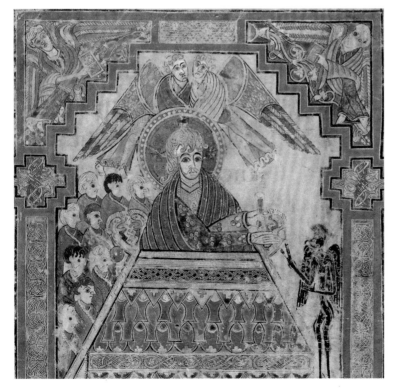

Left Angels accompany Jesus at critical moments in his life. Here they protect him at his temptation by the Devil. (f. 202v)

Opposite Angels guarding the sepulchre where Jesus lies. The words *UNA / AUTEM SAB/BATI UALDE DELU[culo]* (John 20.1) begin the account of the women approaching the sepulchre. (f. 285r)

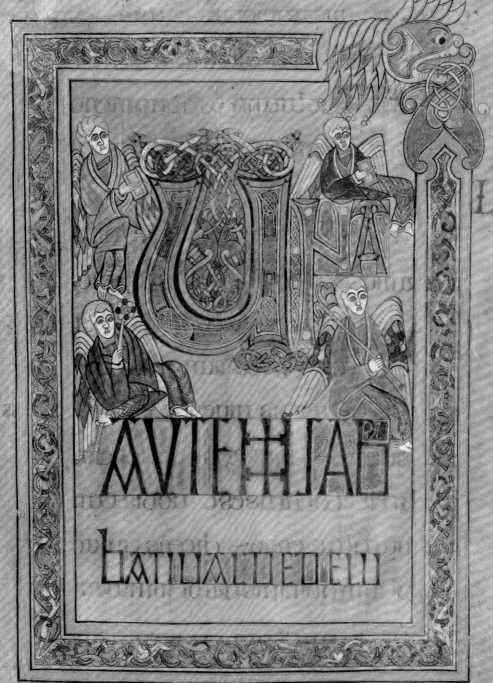

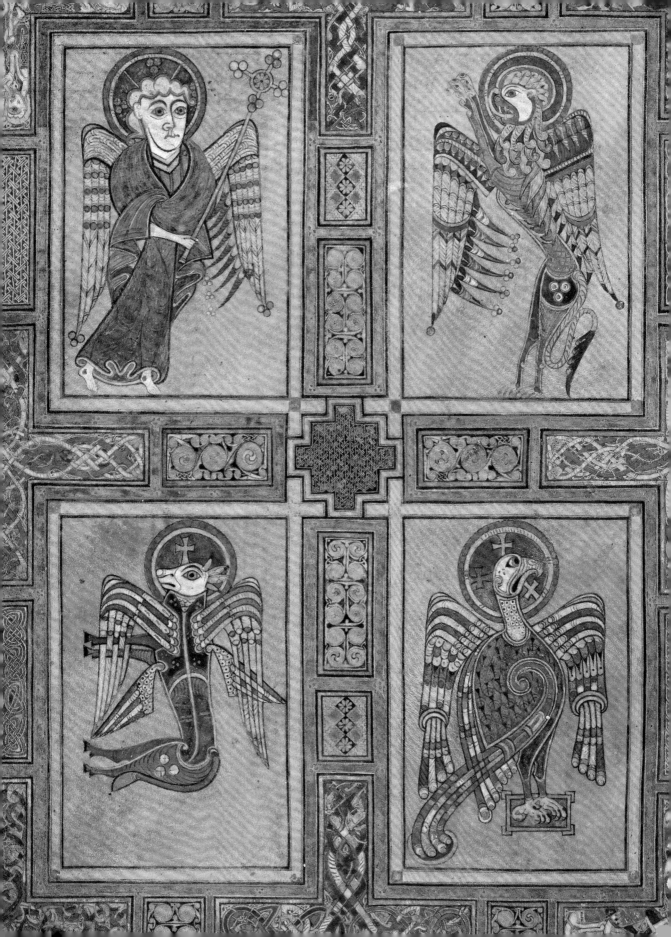

Opposite Evangelist symbols prefacing Matthew's Gospel: the man of Matthew, the lion of Mark, the eagle of John, and the calf of Luke. All have haloes and wings. (f. 27v)

Above The Evangelist symbols preceding John's Gospel are arranged around a saltire cross and run anti-clockwise from the top. (f. 290v)

V. THE EVANGELISTS

Full-page portraits survive only of Matthew and John. Matthew (f. 28v), clad in a purple cloak, holds his Gospel as he sits on a high-backed throne, his feet on a cushion [p. 56]. The symbols of his fellow Evangelists are arrayed around his throne. His gaze is a little disconcerting, as his left eye lacks a pupil.

John (f. 291v) is an imposing figure [p. 57]. His halo bears a strong resemblance to the round church built over 'the Lord's Sepulchre' in Jerusalem, with its corridors, three rotundas and twelve supporting columns. That church had been described to Adomnán by Arculf, a pilgrim from Gaul, who visited Iona on his return from the Holy Land late in the 7th century.[21]

The symbolism of the Evangelists originated in the prophecy of Ezekiel (1.4–11): 'behold, a whirlwind came out of the north … in the midst thereof the likeness of four living creatures … the face of a man, and the face of a lion on the right side of all the four; and the face of an ox, on the left side of all the four; and the face of an eagle over all the four …' In the 6th century, Gregory the Great offered clarification: Christ was a man when he was born, a calf in his death, a lion in his resurrection, and an eagle in his ascension to heaven.[22]

Prefacing Matthew's Gospel, the symbols on f. 27v are set in framed panels around a cross [opposite]. Interlaced snakes writhe in four T-shaped panels at the outer edges of the frame. In the corner panel lower right, four figures are entwined, their necks unnaturally elongated and their heads bent over to recall the Crucifixion.

On f. 129v, prefacing Mark, the symbols are arranged within yellow circles around a yellow-edged cross [p. 1]. Another winged figure is in the frame above the man. Stressing the unity of the Gospels, the lion is accompanied by a calf and an eagle; the calf by an eagle and what, through error, appears to be another calf, where a lion might have been expected; the eagle by a lion and a calf. The decoration of the cross and outer frame includes snakes, peacocks, vines and chalices.

On f. 290v, the symbols preceding John are arranged around a saltire cross [p. 55]. All have wings. The man's arms are crossed; in each hand he holds a book. The lion's mouth is open, with its tongue extended, while red snakes enter the mouths of the lions at each terminal of the cross.

The symbols page (f. 187v) that concludes Mark's Gospel is unorthodox [p. 30]. Two lions, symbol of Mark, stretch from top to bottom on either side of the page, one leg of each forming a saltire cross in the centre of the page. To the right and left of the cross are a winged lion (of Mark) and a figure identified in red as *angelus domini* (the angel of the Lord). Rather than an incomplete representation of the Evangelist symbols, this may be a reference to the announcement by the angel that Christ had risen from the dead (Mark 16.5–7).

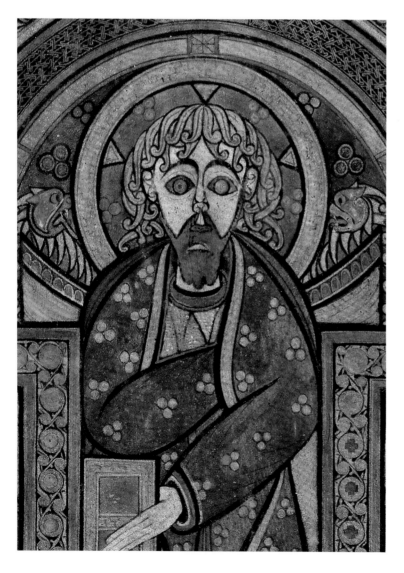

Left The Evangelist Matthew, clad in a purple cloak, holds his Gospel book. (f. 28v)

Opposite The Evangelist John portrayed as a scribe: he holds a pen in his right hand, and his inkwell, made from a cow horn, is placed below his throne, above his right foot. (f. 291v)

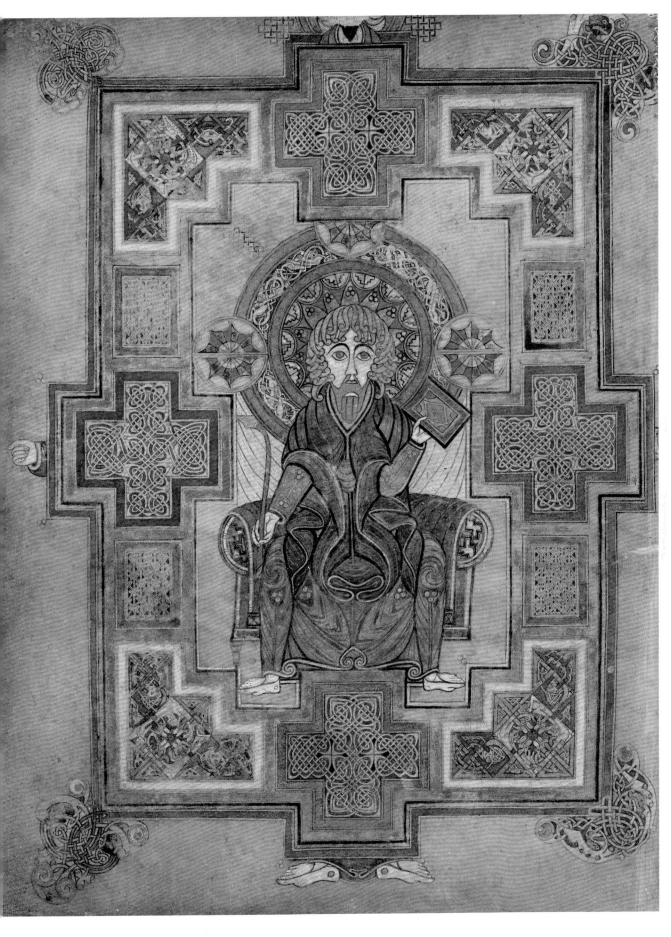

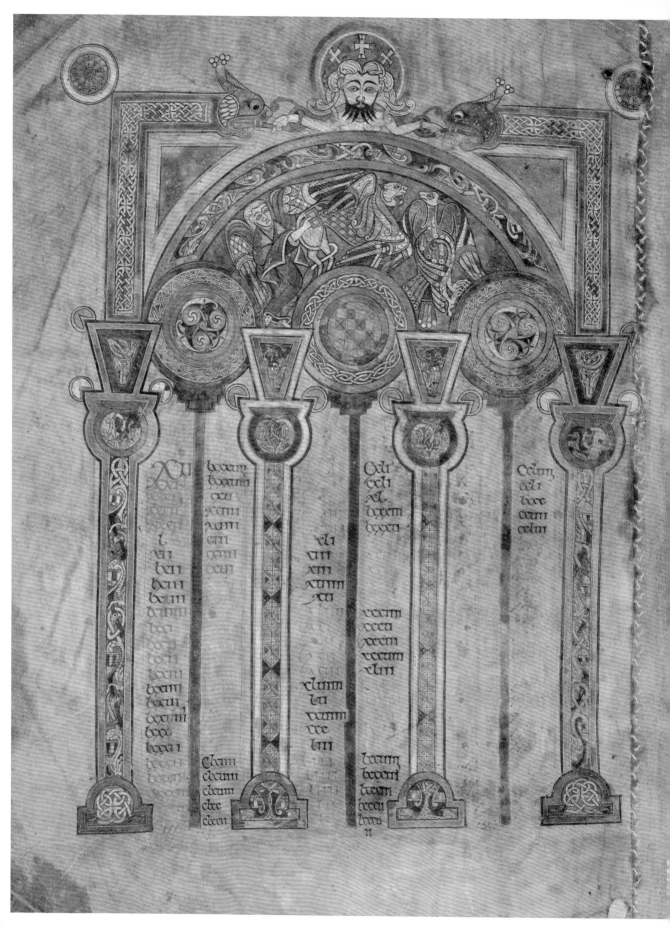

VI. ANIMALS

The lion, fish, snake and peacock comprise the basic vocabulary of the animal ornament. Along with other animals and exotic composite creatures, they form a recurring interplay of Christological imagery. The *Physiologus*, a Greek text of animal lore, probably dating from the 4th century, contained many of the beliefs inspiring the decorative programme of the Book of Kells, while Isidore of Seville's *Etymologies* of *c.* 623 circulated widely.

Lion

The lion represented the house of Judah, from which Jesus was descended: 'our Saviour, the spiritual lion of the tribe of Judah, the root of David', in the description of the *Physiologus*.[23] The lion was 'the strongest of beasts, who hath no fear of any thing he meeteth' (Proverbs 30.30). Profile lions on major pages – ff. 114v, 124r, 130r – are represented with strong, bared teeth [pp. 39, 29, 31].

Above the canon tables on f. 2v, Jesus grips the extended tongue of a lion on either side of him [opposite]. The placing of a human figure between two lions reflected the prophecy, 'You will be revealed in the midst of two animals', at the opening of the Old Latin version of the Canticle of Habakkuk. In Christian exegesis the two lions referred to the two Testaments, Old and New; to the Transfiguration, where Christ was revealed between Moses and Elijah; and to the Crucifixion, where Christ hung between two thieves, the three crosses being depicted graphically here within Christ's halo.[24]

According to the *Physiologus*, the lion cub was born dead, and was watched over by the lioness 'for three days until its sire arrives on the third day and, breathing into its face on the third day, he awakens it'.[25] The parallel with Christ's rising from the dead is explicit. Emanations from the mouths of lions are represented, in a variety of forms, on ff. 72v [left], on 124r, where a vine appears [p. 29], and 29r, where a eucharistic host emerges.

At the word *Homo* beginning Luke 16.19–31 on f. 254r, the *H* is given the form of an athletic lion [left], perhaps in reference to the use of the word *homo* (man) to refer to Christ's human nature.

Panther

For Pliny, the chief characteristic of the panther was its sweet breath, which attracted and stunned other animals. It resembled the lion in certain respects. According to the *Physiologus*, 'If the panther awakens from his sleep on the third day, he roars out in a loud voice and many a pleasant fragrance issues from his voice. Those … hearing his voice, follow its pleasant fragrance.' The *Physiologus* claimed, 'our Lord Jesus Christ who is the true panther draws to himself all humankind … through his incarnation'. The only creature who fears the panther's voice is the dragon,[26] who became identified with the Devil. Thus the panther became another potent symbol of Christ. Isidore remarked that the panther was 'ornamented with tiny round spots'.[27] On f. 327r [below] a long, red, bifurcated tongue, standing for 'its pleasant fragrance', emerges from the mouth of a blue feline; with its spots (arranged in groups of three) and in the absence of a lion's mane, this should be identified as a panther. Placed in the middle of the account of the raising of Lazarus from the dead (John 11), it represents Jesus, in the form of a panther, issuing his sweet, reviving breath in the direction of Lazarus.

Below A panther, representing Christ, issues his sweet breath as Jesus raises Lazarus from the dead. (f. 327r)

Below A fish, drawn with great skill using only pen and ink, forms the bar of the *t* of *Et*, as Jesus goes again into Galilee (John 4.3). (f. 299v)

Fish

Commonly carved on walls and funerary slabs, the fish had been a symbol of Christ since the 2nd century, from the analogy with new converts swimming in the waters of baptism. Augustine indicated that the fish denotes the mystical name of Christ, from the initial letters of the words 'Jesus Christ, Son of God, Saviour' in Greek forming the Greek word for fish, *icthus*.[28] Where it appears, infrequently, in the Book of Kells, the fish tends to resemble a salmon. On f. 158v it forms the bar of the *t* of the initial word *Et* [p. 8], and towards the end of f. 243v it acts as a line-filler. On the *Chi Rho* page (f. 34r) [p. 2] a fish is caught by an otter, symbolizing the consumption of Christ's body in the Eucharist. The fish is used in direct association with the face or name of Jesus as a suprascript abbreviation bar on f. 179v [p. 76]. At John 4.3 (f. 299v) [below], Jesus 'went again into Galilee' (*Et abiit iterum in galileam*). His face is not shown, but his properties are given expression in the initial letters: a lion's head, a lozenge containing two crosses, and a fish executed in pen and ink with stunning calligraphic expertise.

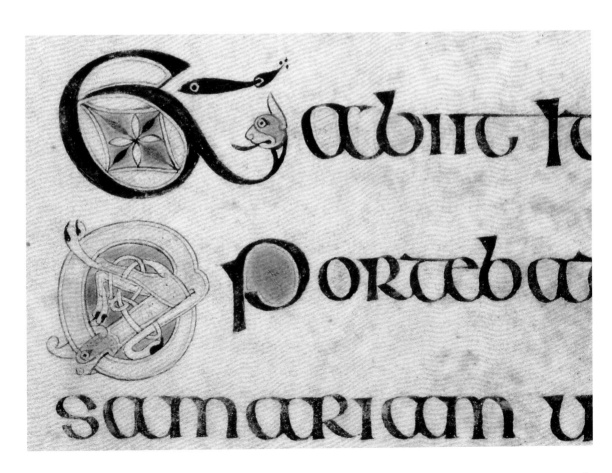

Snake

The snake or serpent was responsible for the Fall of Man, owing to its role in Man's loss of innocence in the Garden of Eden (Genesis 3.1–5): hence it was synonymous with the Devil. But it was also a common symbol of Christ's resurrection from the dead: as Isidore commented, 'Snakes are said to live for a long time, because when they shed their old skin they are said to shed their "old age."'[29]

The snake is a major decorative element in the Book of Kells. On f. 114v, at Christ's Passion, much of the border is composed of snakes in anticipation of the resurrection. The snake could also be formed naturalistically into an initial letter *S*. Snakes dominate the decoration of f. 292r, the first page of John's Gospel [p. 35]. At the opening of Mark's Gospel (f. 130r) [opposite] the heads of four snakes meet at the base of the *N* of *INITIUM*, forming a cross and implying the unity of the Evangelists. On f. 114r [below and p. 70] four snakes form crosses at either side of Jesus' head, their heads meeting this time in discs or eucharistic hosts; one is red, the other is marked with four dots.

In their development from interlace, snakes took on abstract forms. On f. 171v, the heads appear to have grown wings and to be flying towards the viewer.

Below Snakes come together in the cross to the left of Jesus' head on the page which represents him on the Mount of Olives. (f. 114r)

Opposite At the base of the *N* of *INITIUM* at the opening of the Gospel of Mark (see p.31), snakes are interlaced intricately in spirals and knots. Four yellow snakes move inwards to form a cross; two blue snakes move out from the coil. (f. 130r)

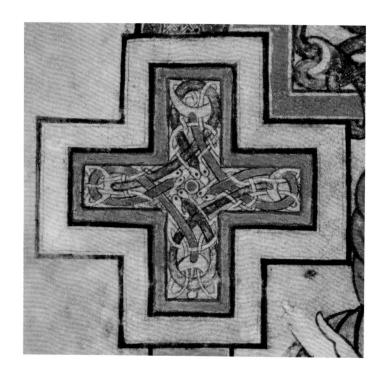

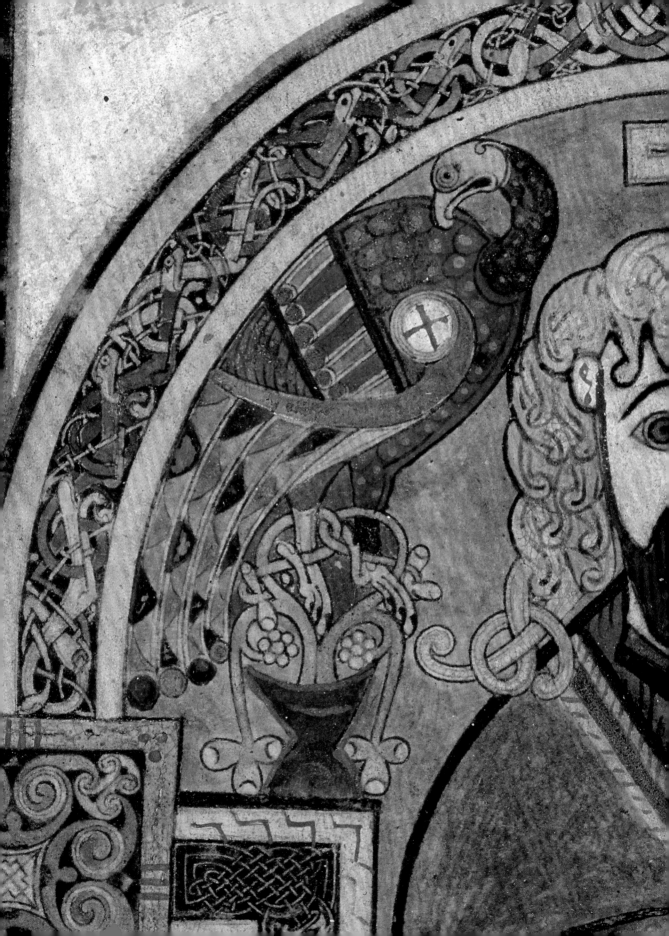

Peacock

The peacock signified Christ's incorruptibility, due to the belief that its flesh does not putrefy. Augustine tested the belief by taking a slice of meat from the breast of a peacock he had been served at dinner in Carthage. A year later, the flesh was only 'a little more shrivelled, and drier'.[30] The head of Christ on f. 32v is both flanked and identified by peacocks [p. 27], in a manner that derives from late Classical models and resembles many examples in Early Christian art. The feet of the peacock on the left are entwined in vines [opposite], while those on the right are entwined in olives, appropriately so as Christ was anointed (*christus*) with oil.

Peacocks are integral to the decoration, appearing in initial letters, at line endings, and in the tightly packed spaces of the major pages, from the canon tables through to the opening page of John on f. 292r [p. 35]. The only major pages from which they are absent are ff. 114r–v. There is normally an attempt to show the length and splendour of their train. At the top of f. 3r [p. 20], peacocks flank Christ and an urn holding vine leaves; reaching down, they grip the tongues of two lions. On f. 8r [p. 25], where the *Breves causae* tell of the birth of Jesus, two peacocks face each other, upside down, above the figure with a book or writing tablet; one stands on the head of a snake, here symbolizing the Devil, as foretold in Psalm 90.13: 'Thou shalt walk upon the asp.'

Opposite The peacock, symbol of Christ, is placed to the left of his portrait (see p. 27). Its feet entangled in vines, it looks down at a eucharistic host on its wing. (f. 32v)

Right The peacock was associated with the sky and with heaven. Here a peacock perches on the words of Jesus in John 6.38, *Quia descendi de caelo* ('Because I came down from heaven'). (f. 309r)

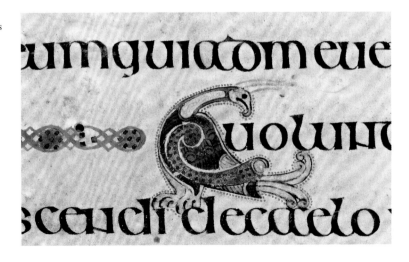

Goat

A she-goat appears on f. 41v, at Matthew 5.18, *donec transeat cae/lum* ('till heaven and earth pass') [below left]. Its presence may perhaps be explained, but only partially. The *Physiologus* made an association between the goat and Christ: as the goat inhabits high mountains, so Christ associates with angels and prophets, and as the goat pastures in the valley, so does Christ in the church, feeding on good works and alms.[31] The drawing of the goat may refer back to f. 41r, and the reference in Matthew 5.14 to 'A city seated on a mountain'.

Stag

The stag was another enemy of the dragon. Chasing the dragon into the cracks of the earth, the stag drinks from a stream, 'then spits out the water into the cracks and draws the dragon out … and kills him'. The analogy is with Christ, who killed the Devil 'with heavenly waters of indescribable wisdom'.[32] The association of the stag with water, and baptism, was suggested by Psalm 41.2: 'As the hart panteth after the fountains of water; so my soul panteth after thee, O God.'

A stag, its antlers terminating in bunches of grapes, faces the end of John 4.46 (f. 302r) [below right]. Jesus came to Cana of Galilee, 'where he made the water wine' (*uenit / ergo iterum in channan galileae ubi fecit / aquam uinum*). The word *aquam*, with its connotations of baptism, seems to have inspired the drawing.

Below left A she-goat stands at Matthew 5.18. (f. 41v)

Below right A stag at John 4.46, in the context of water turned into wine. (f. 302r)

Dove

Adomnán explained that Colum Cille's name in religion, 'Columba', is Latin for dove, and that 'the dove is generally taken allegorically to represent the Holy Spirit.'[33] On f. 201r a figure holds the final letter of *fuit* in the line *Qui fuit Iona* ('who was of Jona'; Luke 3.30), drawing attention to the word *Iona* (the Hebrew for dove) and thus to Colum Cille's name.

Doves with foliage in their mouths represent Genesis 8.11, when Noah sent a dove from the ark to discover if the earth was still flooded. At John 7.40 (f. 314r) [left] a dove holding an olive branch forms the tail of the word *Ex*, perching on *propheta*, as the crowd around Jesus exclaim, 'This is the prophet indeed'.

Wolf

Its tongue lolling out, a wolf pads threateningly across the text of Matthew 16.6 (f. 76v) [below], where Jesus warns against being taken unawares by the teaching of the Pharisees and Sadducees. A few verses earlier, he had made specific references to wolves: 'Beware of false prophets, who come to you in the clothing of sheep, but inwardly they are ravening wolves' (Matthew 7.15); and 'Behold I send you as sheep into the midst of wolves' (Matthew 10.16).

Above A dove with an olive branch, evoking the Holy Spirit, perches on the word *propheta*. (f. 314r)

Below The wolf that appears with the text of Matthew 16.6 resembles the animals of Pictish stones in its joint articulation. The tip of an arrow was added to its tail by Gerald Plunket in the 16th century. (f. 76v)

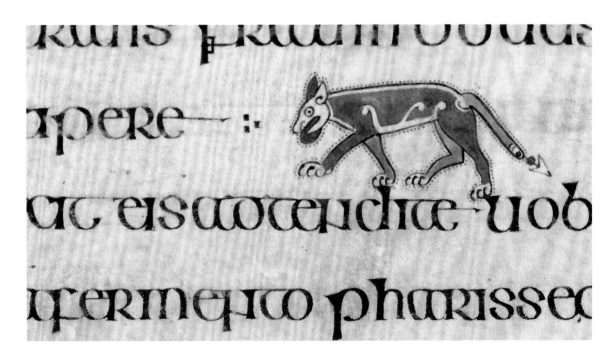

Cat

Domestic cats sit quietly and watchfully, with curled tails, under the initial letters on a few pages. They have a practical function on ff. 34r and 48r, where they apprehend mice or rats in possession of communion hosts [p. 49 and opposite]. The latter scene obliquely reflects Matthew 7.9, several lines below – 'what man is there among you, of whom if his son shall ask [communion] bread, will he reach him a stone?' – and illustrates the practical function of cats in the monastery in preserving the supply of food, physically as well as spiritually. A similar depiction occurs on Muiredach's Cross at Monasterboice.

Hare

The hare is depicted on ff. 87v and 180r in contexts that appear to link its timidity with the behaviour of Peter in denying his association with Jesus. A hare leaping in an attempt to escape a greyhound is drawn on f. 48r [opposite]. This may be a borrowing, though no doubt indirect, from a late Roman depiction of a hunted hare, such as the 4th-century scene of a hare impaled by a child's spear at Piazza Armerina in Sicily. Roman artists noted the hare's supposed fondness for grapes, and an association between the hare and eucharistic grapes may have been the stimulus behind the scene on f. 84v [below], where a hare bites a vine at the terminal of *Et*.

Above A domestic cat, its tail curled up, sits watchfully in the shade of initial letters. (f. 92v)

Below A hare bites a vine growing amidst the decoration of *Et* at the opening of Matthew 19.1, when Jesus departs from Galilee. (f. 84v)

Opposite At the top of the page is a striped cat behind a rat or mouse that has stolen a communion host. In the lower encounter of animals, a hare leaps in an attempt to escape a greyhound. (f. 48r)

mitentE &pulsandu up

tatur ꞏ:

Exuobis homo quemsi

ssus panannumquid

riga ei ꞏ: Autsipiscem

nguid serpentem porri

os cumsitas mali plofas

us uestris ꞏ quantomagis

quuncaelusest dabit ꞏ:

ibus se

quaecumque uultasbona

VII. IMAGING THE GOSPELS

On f. 114r, at Matthew 26.30 [opposite], Jesus is flanked by two smaller figures holding his arms, which are outstretched as though in prayer. The saltire cross formed by his arms and legs and the equal-armed crosses on either side of his head anticipate the Crucifixion. The words *Et ymno dicto / exierunt / in montem oliueti* ('And a hymn being said, they went out unto mount Olivet') are inscribed in the tympanum of the arch that contains the figures. For many years the scene was identified as the arrest of Christ, though Matthew's Gospel does not reach that episode until ff. 116v–117r. On f. 114r the figures flanking Jesus bear no weapons. Drawing on the evidence of an early 9th-century fresco in the Swiss church of St Johann at Müstair, it has been proposed that the image should be viewed as Christ praying on the Mount of Olives, precisely as the text on the page indicates.[34] Other studies have noted liturgical resonances in the image, which occurs opposite Jesus' institution of the Eucharist on f. 113v.[35]

The temptation (Luke 4.9–13) is illustrated on f. 202v [p. 52 and right]. Here Satan urges Jesus to throw himself from the roof of the Temple in Jerusalem in order to demonstrate that angels will save him. The page presents many complexities,[36] partly because again the relevant Gospel passage occurs later in the volume, on f. 204r. Jesus is represented on a shingle-roofed building that resembles an Irish shrine, with lions as finials. Protected by angels directly above him and in the top corners of the page, he holds out a slender glass vessel, possibly a chalice filled with eucharistic wine, in response to the small black winged figure of Satan on the right. Stylized peacocks are placed within the crosses on either side of Jesus. The haloed figure with crossed *flabella* in the centre of the Temple may represent Christ as judge in a Last Judgment scene. Thirteen human figures at the foot of the page and nine to Jesus' right seem to represent the faithful. The Temple and Jesus may represent literally the body of the Church with Christ as its head.

Above The third temptation of Jesus, described in Luke's Gospel: 'And [the Devil] ... set him on a pinnacle of the temple and said to him: If thou be the Son of God, cast thyself from hence'. (f. 202v; see also p. 52)

Opposite Jesus on the Mount of Olives: *Et ymno dicto / exierunt / in montem oliueti* ('And a hymn being said, they went out unto mount Olivet'; Matthew 26.30). The image was misinterpreted for many years as his arrest. (f. 114r)

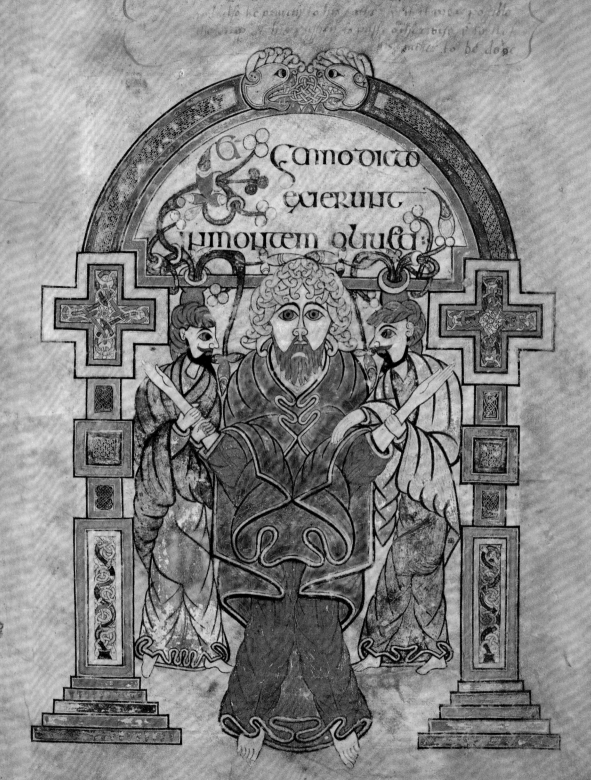

VIII. TEXTUAL ALLUSIONS

Allusions to the Gospel narrative occur throughout the manuscript, but they are not always obvious at first glance. The parable of the seed and the sower (Matthew 13.3–30) is extensive, running from f. 65v to f. 68r, but its illustration is concentrated near the top of f. 67r [below]. A rooster, a strikingly accurate representation of the native jungle fowl (*Gallus gallus*),[37] stands on the word *parabulam* in line 3. He is accompanied by two hens, who may be preparing to eat the seed. The rooster is a familiar component of Crucifixion scenes, alluding to Peter's denial of Christ. In line 5, the parable mentions the *malignus* ('wicked one') who takes away the seed and who, in all likelihood, is shown curled up awkwardly within the initial letter at the start of line 3. The scene may in part signal obliquely that Peter's denial of Christ was the work of the *malignus* or Devil.

On f. 253v, the initial *N* of the phrase *Nemo seruus potest duobus dominis seruire* ('no servant can serve two masters'; Luke 16.13) shows two men pulling each other's beards, linked to a small human figure constrained within an initial *A* four lines down the page. Combined, the images seem to show the conflict entailed in serving two masters.

An insect on f. 63r has been identified as a fly, consistent with its place at the beginning of Matthew 12.24: it emerges from the initial letter *P*, as the Pharisees declare, 'This man casteth not out devils but by Beelzebub, the prince of the devils'. In Jerome's interpretations of Hebrew names, incomplete versions of which occur in the Book of Kells, the name 'Beelzebub' means 'having flies' or 'man of flies' (Lord of flies).[38]

Below The parable of the seed and the sower is illustrated, indirectly, by a rooster with two hens. (f. 67r)

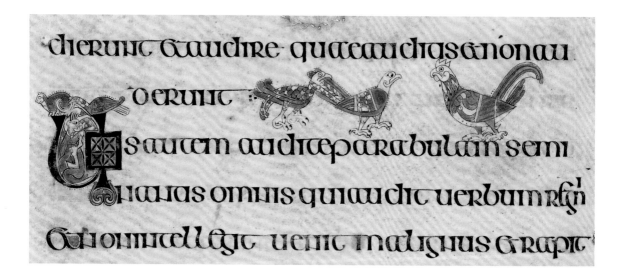

pauper familias dicentes hii nouis
simi una hora fecerunt Et pares
illos nobis fecisti Qui portauimus
pondus diei Et estum. At ille res
pondens uni eorum dixit amice
non facio tibi iniuriam nonne ex
denario conuenisti mecum Tolle
quod tuum est Et uade uolo autem
Et huic nouissimo dare sicut Et
tibi aut non licet mihi dare mea
Et quod uolo facere An oculus
tuus nequam est Quia ego bo
nus sum Sicerunt nouissimi pri
mi Et primi nouissimi Multi enim
sunt uocati pauci uero electi
Ascendens ihs hierusoli
mam adsumpsit xii dis

apulos suos secreto Et aitillis ec
ce ascendimus hierusolimam
Et filius hominis tradetur prin
cipibus sacerdotum Et scribis Et
condempnabunt eum morte Et tra
dent eum gentibus ad deludendum
Et flagellandum Et crucifigendum
Et tertia die resurget
Tunc accessit ad eum mater fili
orum zebedei cum filiis suis ad
orans Et petens aliquid ab eo qui
dixit ei quid uis Et illa dixit dic
ut sedeant hii duo filii mei unus ad dexte
ram tuam Et unus ad sinistram
in regno tuo Respondens autem
ihs dixit illis nescitis quid petatis
potestis calicem bibere quem

Above The opening recounting Jesus'
journey to Jerusalem (Matthew 20.11–22).
On the right-hand page he is depicted
travelling on an ass; his foot points back to
the facing page, where the final two lines
describe that action. (ff. 88v–89r)

Jesus enters Jerusalem

Matthew's account of Jesus travelling to Jerusalem with his twelve disciples
(20.11–22) is illustrated with a drawing on f. 89r of Jesus riding low on an
ass, perhaps side-saddle in an act of humility [above]. Jesus' foot points
back to the words *Et ascendens iesus hyerusoliman* ('and Jesus going up to
Jerusalem'; Matthew 20.17) at the foot of f. 88v, while above him lines
1–2 read *Et ait illis ecce ascendimus hyerusolimam* ('And he said to them,
"Behold we go up to Jerusalem"'; Matthew 20.18), acting almost as a
headline to the page. As so often with the Book of Kells, the decoration
does not coincide precisely with the text, as it is not until Matthew 21.2
(f. 90v) that Jesus requisitions an ass and a colt and enters Jerusalem.
On f. 255v Jesus is again shown riding [p. 93], looking across the opening
and down to the text of Luke 17.11, *in hierusalem transibat* ('he was going
to Jerusalem'). His hand, clutching reins, is raised in benediction. That his
animals in both cases resemble horses rather than asses can be explained by
the probability that the ass was not known in Ireland in the 9th century.[39]

Judas's betrayal

Judas's betrayal of Jesus is shown in an indirect form on f. 116v [below], accompanying text from Matthew 26.47 that begins *Adhuc ipso loquente ecce iudas* … ('As he yet spoke, behold Judas, one of the twelve, came, and with him a great multitude with swords and clubs, sent from the chief priests and the ancients of the people'). The act that follows on line 14, where Judas kisses Jesus as a betrayal leading to Jesus' arrest, is represented here at the beginning of the line. The *A* of *Adhuc* takes the form of two upright lions embracing, that on the left biting the neck of that on the right. While the action of the left-hand lion is not strictly a kiss, the intent of the image is unmistakable. The incident appears in several contemporary manuscripts, including the Stuttgart Psalter and the Drogo Sacramentary, and on high crosses at Clonmacnoise and Monasterboice; the closest parallel in posture is in the scene on the base of the east side of the Market Cross at Kells.[40] In the use of lions to represent both figures there is an accord with Augustine's observation that the Devil and Jesus could take the same form: 'both Christ and the Devil are called a lion'.[41]

Below In the text where Judas arrives with a mob to arrest Jesus his betrayal with a kiss is prefaced by the letter *A* of *Adhuc* at the beginning of line 4, formed by two lions representing the two figures. (f. 116v)

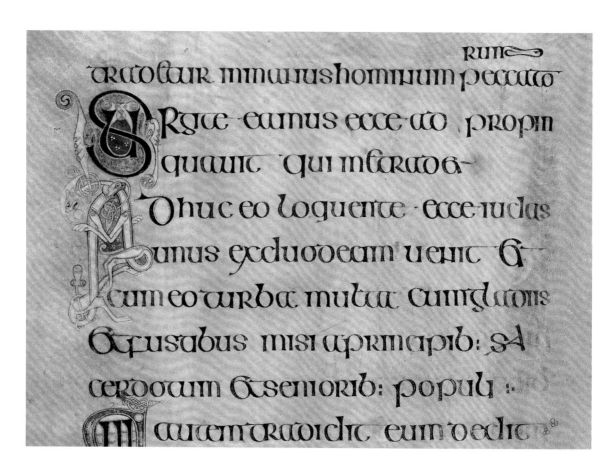

Christ's Agony

At the end of f. 277r line 9, a lion, symbolizing Christ, looks back along the line [below]. Above him, and to his left, Christ's Agony in the Garden of Gethsemane is described: *et factus est sudor eius sicut guttae sangui/nis decurrentis in terram* ('And his sweat became as drops of blood, trickling down upon the ground'; Luke 22.44). The words *guttae sangui/nis* (drops of blood) are immediately above the lion. Red dotting around the animal is extended horizontally in two lines to its right, while above these lines irregular dots, connected by diagonal lines to the horizontals, represent Christ's blood trickling to the ground.

On f. 277r, line 2, Jesus prays to be spared the ordeal to come: *Pater si uis transfer calicem hunc / a me*; ('Father, if thou wilt, remove this chalice from me'; Luke 22.42). No chalice is depicted beside the word *calicem*, but a chalice painted in red and yellow is placed close to the foot of the facing page, f. 276v, with vines, grapes and wheat pointing up to the word on f. 277r.

Below At Christ's Agony in the Garden of Gethsemane, 'his sweat became as drops of blood' (Luke 22.44) – represented by drops around the animal and at the end of the line. (f. 277r)

Figures and faces

One of many occurrences of the profile blond head of Jesus is at Mark 14.61 (f. 179v) [below]. When the high priest asks, 'Art thou the Christ, the Son of the Blessed God?', Jesus' emphatic response, 'I am', is echoed in the decoration of his abbreviated name *ihs*. Jesus' head is flanked by two of his symbols, the lion and the fish.

Human figures include Lot's wife on f. 257v [right], at the phrase *Memores estote uxoris loth* ('Remember Lot's wife'; Luke 17.32). Pontius Pilate is represented on f. 182r as a man almost literally torn in two, his arms outstretched and holding on, as though in desperation, to his own body and hair.

Above The head of Lot's wife appears in the initial *M* at the beginning of *Memores estote uxoris loth*, 'Remember Lot's wife' (Luke 17.32). (f. 257v)

Below The profile head of Jesus is set in the *h* of *ihs* – the abbreviation of *iesus* – at Mark 14.61, where he reveals himself as 'the Christ, the Son of the Blessed God'. (f. 179v)

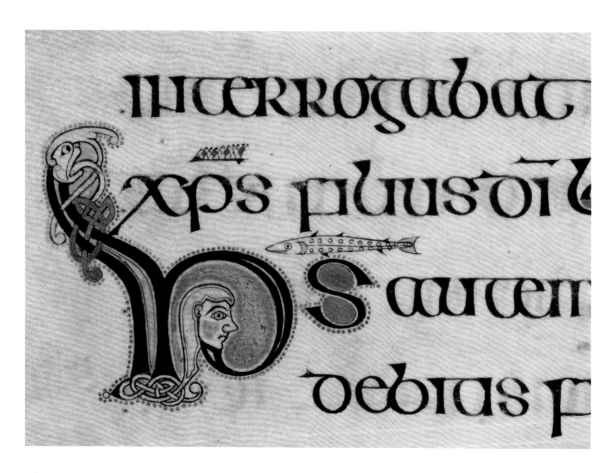

Speaking and hearing

Allusions to speaking and hearing the sacred text are among the most common decorative devices in the Book of Kells, having their inspiration in passages of scripture. The last words of David, for example, were 'The spirit of the Lord hath spoken by me, and his word by my tongue' (2 Samuel 23.2). The lion is normally represented with an extended tongue, reflecting its use as an instrument of scripture.

Lions in initial letters commonly touch their mouths or ears in forming and giving visual expression to the words *ait* or *dicebat* ('he said') or *audiebat* ('he heard'). Two lions forming the first two letters of the word *Dicebat* (f. 252v; Luke 16.1) hold their paws to their mouths [below]; the first lion employs his other paw to point to his ear. At Matthew 26.52 on f. 117r [left], a lion's pose indicates that the direct speech of Jesus follows. He contorts his rear paw into his mouth to form the initial *T* at *Tunc ait illi iesus conuerte gladi/um tuum in locum suum* ('Then Jesus saith to him: Put up again thy sword into its place') at the point in the text where one of those with Jesus has cut off the ear of a member of the arresting party.

Above and below Lions hold their paws to their mouths to indicate that Jesus' speech follows (Matthew 26.52 and Luke 16.1). (ff. 117r, 252v)

Overleaf Jesus urges *Orate autem ut hieme non fiat* ('pray ye that these things happen not in winter'; Mark 13.18). (f. 173r)

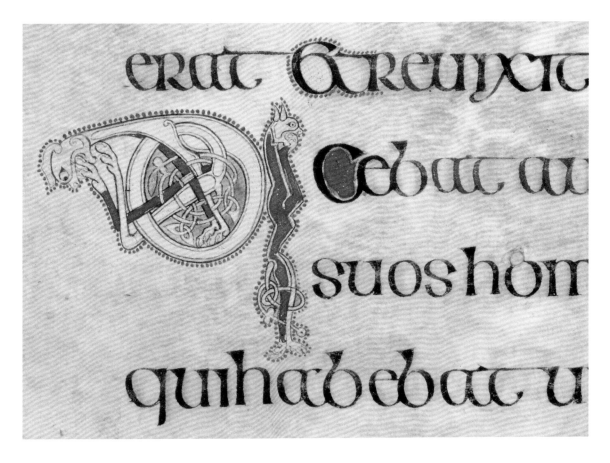

ainehar

eautem prig

milus diebus

Rate autem

fuga uestra

Runt enim c

tales quales

uo creaturae qui

tatur tollere ues

suum

taurab: & uiuorietab:

udhieme nonfiat

elsabbato

es illtribulationes

louperuerunt abin

mcondedit ds̅s

ascenderit tolle · Et aperto ore eius in
uenies ibi statterem illum sumens da
eis pro me · Et te ·

IN illa hora accesserunt discipuli ad
ihm dicentes quis putas maior est
inregno caelorum · Et aduocans ihs par
uulum statuit eum inmedio eorum
Et dixit amen dico uobis nisi conuer
si fueritis · Et efficiamini sicut paruu
li non intrabitis inregnum caelorum ·
Quicumque ergo humiliauerit se
sicut paruulus iste · hic erit mai
or inregno caelorum · · Et quissus
ciperit unum paruulum tale in
nomine meo me suscepit · ·

QUi autem scandalizauerit unum
de his minimis istas qui in me credun

SCRIBES AND ARTISTS
SCRIPT, PRICKING AND RULING, CORRECTING

Opposite An exaggerated form of *a* is used at the end of line 4 for the word *ad*, at the point where Jesus urges the apostles to become like little children (Matthew 17.26–18.6). (f. 81v)

Above A substantial omission from Mark 6.17–18 is marked with a dotted red cross. Another red cross at the foot of the page signals the missing text. (f. 146v)

Below The word *principes* ('chief'; Luke 22.52) was corrected to *principis* through the expunctuation of *e* and its replacement, above, with the letter *i*. (f. 278r)

The script takes two forms: Insular majuscule and minuscule. Most pages were written in majuscule, a higher grade of script, in which the uprights of *b*, *l* and *t* form curves rather than vertical lines. The letter *a* resembles *oc* in form, though the uncial *a* (like a capital *A* in modern typeface) is also used, particularly at line ends. On f. 81v [opposite] an exaggerated form is used for *ad* at the end of line 4. Minuscule, a more angular and compressed script, was used intermittently.

To achieve a justified right margin, the letters *m*, *n* and *u* were commonly turned on their sides, while the final letter of a line could be placed below the rest of the word. Where calligraphic effect took precedence over legibility, the scribes resorted to unorthodox syllabification: on f. 213r the word *ab* begins and ends, bizarrely, on separate lines. Some lines of text were ended in spaces on the line above. Later Irish scribes termed this device 'head-under-wing' (*ceann fa eite*) or 'turn-in-the-path' (*cor fa fasam*). The scribes could be erratic, resulting in meaningless readings. At John 5.3 (f. 303r), *caelorum* ('of the heavens') is an error for *caecorum* ('of blind') in the passage, 'In these lay a great multitude of sick, of blind, of lame …'

There were sporadic campaigns of correction. A lengthy omission on f. 146v was made good at the foot of the page [left], the reader guided by elegant crosses formed from red dots. On f. 278r, at Luke 22.52 [below], *principes* ('chief") was changed neatly to *principis*: the scribe expunged the *e* with a dot and inserted an *i* above it.

Major pages were usually executed on single leaves, but the *Chi Rho* page (f. 34r) [p. 2] had text on the verso. This was pricked and ruled with great care to ensure that the decorated side was not punctured.

THE SCRIBES

Scribes held a high status in medieval Ireland. The Book of Kells was produced by at least four major scribes, operating at different levels of expertise, and with varying approaches to the combination of script and ornament. All were trained in the same scriptorium styles. Identifications are not always clear, and the divisions proposed here might be refined further. More than one hand can be seen on a number of pages. It is hard to escape the conclusion that the Book of Kells was assembled, by Scribe B, from texts copied over a lengthy period. It gives no appearance of having been planned coherently in advance and executed strictly to that plan.

SCRIBE A

Scribe A copied all of John's Gospel (ff. 292v–339v), and began both the preliminary texts (ff. 1r, 8v–19v) and Mark's Gospel (ff. 130v–140v). He may have had some involvement in the planning and design of the canon tables. On ff. 5v and 6r the canon tables were by Scribe B, working to a grid pattern which was superimposed over pricking and ruling for 19 lines of single-column text [p. 14 below]. As that format had been used by Scribe A for the preliminary texts, it appears that Scribe B adapted sheets of vellum previously prepared by A for a different purpose.

Scribe A was sober and conservative, writing in a style that resembles that of the 8th-century Durham Gospels (Durham Cathedral Library, MS A.II.17). He was probably the earliest of the scribes. It may be possible to identify him with Connachtach, an abbot of Iona who died in 802; according to the Annals of the Four Masters, he had a reputation as a 'choice scribe' (*scribneoir tocchaide*). Scribe A's letter forms are a little more compact than those of the other scribes, with shorter ascenders. His lines of text are slightly longer. He uses a more upright *s*, and a distinctive, rounded form of initial *N*.

He tended not to decorate his work, leaving others to complete the page. On some pages, such as f. 311r, where Jesus is urged to go to the feast of tabernacles in Judea (John 6.64–7.1), this practice resulted in a page which is marvellously coherent, and without flamboyance [opposite]. On f. 296v [above] Scribe A left no space for decorated initial letters, so that an initial *R* had to be added in the margin.

Above Scribe A here left no space for initial letters. The first *R* was supplied at the time; the two below appear to have been added in the 16th century by Gerald Plunket. (f. 296v)

Opposite Line 2 begins *Et dicebat* ('He said'), and Scribe A indicates Jesus' speech by the lion's tongue in *Et*. (f. 311r)

credentes & quis traditurus esset eum :·
Et dicebat propterea dixi uobis quia
nemo potest uenire ad me nisi fuerit
ei datum a patre meo & hoc multi discipu
lorum eius abierunt retro et iam non cum
illo ambulabant ·:· Dixit ergo ihs ad
xii numquid & uos uultis abire ·:·
Respondit ergo ei simon petrus dne ad
quem ibimus uerba uitae aeternae ·
habes & nos credidimus & cognouimus
quia tu es xps filius di ·:·
Respondit eis ihs nonne ego uos xii elegi
& unus ex uobis zabulus est dicebat ·
autem iudam simonis scariothis hic enim
erat traditurus eum cum esset & unus ex
Post haec autem ambulabat ihs in ga
lileam non enim uolebat in iudeam
ambulare · quoniam quaerebant eum

SCRIBE B

Scribe B worked on the final canon tables (ff. 5v–6r), and supplied canon numbers and rubrics (titles or headings, often in red ink) to the earlier canons on ff. 1v–5r [pp. 20–21]. His most substantial contribution was to complete the preliminary texts on ff. 20r–26v, using minuscule script and purple, yellow, red and carbon black inks [p. 42 top, and opposite]. These are among the most vibrant pages of the manuscript.

Scribe B seems to have worked through sections of the manuscript, attempting to complete it textually and to supplement the decoration. He added rubrics in spaces left by A in the preliminary texts on ff. 11v, 13r, 15v, 16v and 18r, in the first three of which he also provided display capitals [pp. 6–7]. He completed Matthew's Gospel between f. 125v and f. 129r, mostly in carbon black. He added a brief rubric for Mark in red ink on f. 129r and he marked the end of Luke's Gospel and the beginning of John's on f. 290r with exuberant rubrics which, with repetition, almost cover the page.

Scribe B had an inclination to intervene on pages that the original scribe would have been justified in regarding as completed. The words of Matthew 26.31, *Tunc dicit illis iesus omnes uos scan[dalum]* ('Then Jesus said to them: All you shall be scandalized in me this night'), were already highlighted in display capitals on f. 114v, but he copied them precisely, on the same page, in red with purple infills, down to the incomplete final word [p. 26 bottom left]. On f. 183r, he placed the text *Et crucifigentes eum diuiser[runt]* ('and crucifying him, they divided'; Mark 15.24) in a previously blank space, lifting that line from the same position on the facing page, f. 182v, without any clear thought as to its purpose.

B was the scribe who cancelled f. 218v [p. 84], as that page contains the same text as the introduced f. 219r facing it, using his characteristic red ink to draw crosses around and within the text and to add eucharistic images at the corners. Chalices and vines, and interlinear scrolling, mostly in red with yellow, can be seen on many pages, often imposing on decoration already in place. Scribe B is an obvious candidate as the author of these interventions. He comes across as a supremely talented but restless personality, who was active when the scribes who had gone before him were not in a position to offer guidance or restraint.

Above A page by Scribe C was cancelled by Scribe B with red crosses around and through the text, as the same text was on the facing page that had been inserted. (f. 218v)

Opposite Scribe B used purple, red, carbon black and yellow inks for the *Breves causae* of John. An outstretched lion and an elaborate *o* form the first two letters of *Iohannis*. (f. 24r)

Iohannis testimonium periubit de ipso dicens
non sum dignus corregiam calciamenti
eius soluere · Ecce agnus dei ecce
qui tollit peccatum mundi ··

Ostendit ihs discipulis suis ubi maneret et
secuti sunt eum · Ubi ihs deaqua uinum fecit
in channa galilae ·· Eiecit ihs detemplo om
nes uendentes et dixit domus orationis est
domus patris mei · Qui non renatus fuerit denouo
exaqua et spu sco non intrabit in regnum di ··
Ubi baptizat ihs et dixit iohannis discipulis
ego non sum xps · Ubi secessit ihs aiudea et
uenit in samariam · · pter bibere et ih
sedens super puteum mulierem samaritanam
et discipulis suis alii laborauerunt et uos inla
borem ipsorum introistis · Quia propheta sine
honore est in patria sua · Et ad ubi filium reguli sana
uit ··

24

Ae autem praegnantabus & nutrientabus in illis diebus :·

Orate autem ut non fiat fuga uestra hieme uel sabbato

Erit enim tunc tribulatio magna qualis non fuit ab initio mundi usque modo neque fiet

Et nisi breuiata fuissent dies illi non fieret salua omnis caro sed propter electos breuiabuntur dies illi :·

Tunc si quis uobis dixerit ecce hic xps aut illic nolite credere

Surgent enim pseudoxpi & pseudo prophetae & dabunt signa magna & prodigia ita in errorem inducantur si fieri potest etiam

SCRIBES C AND D

Scribes C and D copied most of Matthew, Mark and Luke, integrating scribal and artistic activity. Scribe C copied ff. 35r–87v (Matthew) [p. 69], 141r–163v (Mark) [p. 8], 189r–202r [p. 32] and 203v–243v (Luke), and perhaps ff. 29v–31v (Matthew). Scribe D is on ff. 88r–125v (Matthew) [p. 73], 164r–187v (Mark) [pp. 78–79], and 243v–289r (Luke) [p. 75].

Scribe C's script is steady and practised, with a measured skill in the formation of initials around animal forms, such as the decoration of the genealogy of Jesus on f. 200r, with its close relationship between the final letter of *maath* and the foot of the warrior in the lower right corner [below right].

Fitting less text to the page than C, Scribe D's letters have longer ascenders and a slightly greater height, around 2 mm more for *b* and *d*. His *o* takes a more oval form. His ink is a little darker than C's. He made more use of elongated letters or words, especially at the ends of verses, and had a tendency to isolate them centrally. On f. 271v [pp. 90–91], both *uestras* and *eius* are centred, the latter ending with the letter *s* shaped into a free-flowing cross, conceived with breathtaking imagination.

Scribe D was capable of brilliant improvisation, markedly so in his painting of Jesus entering Jerusalem (f. 255v) [p. 93], which is integrated with the words *unum de* ('one of'; Luke 17.2) above it. The tonsure is formed by exaggerating the serif of *m*, and the mane of the ass flows from the letter *e*.

Opposite Scribe D: in line 12 a lion's head, forming the bar of the *T* of *Tunc* (Matthew 24.23), gazes down at the prediction of the coming of false Christs and false prophets. (f. 104r)

Below Scribe D: the initial letters of key words in Christ's address to the blessed at the Last Judgment (Matthew 25.35–37) are arranged in a vertical line. (f. 110r)

Below right Scribe C: in Jesus' genealogy (Luke 3.26), a warrior holds a spear. His genitalia are parallel to the spear, referring to Jesus' creation and to his death. (f. 200r)

THE ARTISTS

Three artists were identified by the art historian and archaeologist Françoise Henry: the 'Goldsmith', the 'Portrait Painter', and the 'Illustrator'. The Goldsmith's use of silvery blue and golden yellow, and 'the clear-cut incisiveness of his incredibly intricate patterns', are suggestive of metalwork. She saw his hand in the eight-circle cross (33r) [p. 18], the *Chi Rho* (34r) [p. 2], the top section of the canon tables on 5r [p. 21], and the openings of the Gospels on 29r (*Liber*), 130r (*Initium*) [p. 31], and 292r (*In principio*) [p. 35]. In Henry's scheme, the 'Portrait Painter' was responsible for the portraits of Christ (32v) [p. 27] and of Matthew (28v) [p. 56] and John (291v) [p. 57], and perhaps for the symbols page for Matthew's Gospel (27v) [p. 54]. The 'Illustrator' painted figures – 'weird and immobile but impressive' – on 7v (Virgin and Child) [p. 22 and below], 114r (the 'arrest', now interpreted as Christ on the Mount of Olives) [p. 71], 202v (the Temptation) [p. 70], and perhaps 290v (Evangelist symbols) [p. 55].

William O'Sullivan preferred to view 'Portrait Painter' and 'Illustrator' as a single artist. Jonathan Alexander proposed, 'with much uncertainty', a division between two principal artists, the first artist painting ff. 32v, 33r, 34r and perhaps 130r [pp. 27, 18, 2, 30], while the other painted ff. 7v–8r, 28v, 29r, 114r, and 291v–292r [pp. 22, 25, 56, 71, 57, 35]. Alexander expressed doubt about ff. 202v and 290v [pp. 70, 55] (perhaps by the first artist), and tentatively attributed ff. 27v, 129v and 188r [pp. 54, 30, 33], along with most of the canon tables, to the second artist.[42] Little attention has been paid to the question of whether those who produced the manuscript's major pages were also its scribes.

Below The Virgin and Child page (see p. 22) has been regarded as the work of the 'Portrait Painter'. (f. 7v)

Opposite A detail of the *Chi Rho* page (see p. 4), attributed to the 'Goldsmith'. Snakes, coloured blue, form a saltire cross among yellow lions and green peacocks. (f. 34r)

Overleaf At Luke 21.19–21, Jesus foretells the destruction of Jerusalem. The text is laid out spaciously by Scribe D, with purple, denoting the Passion, the dominant colour in the initials. (f. 271v)

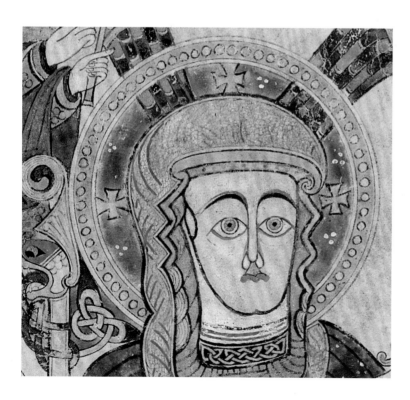

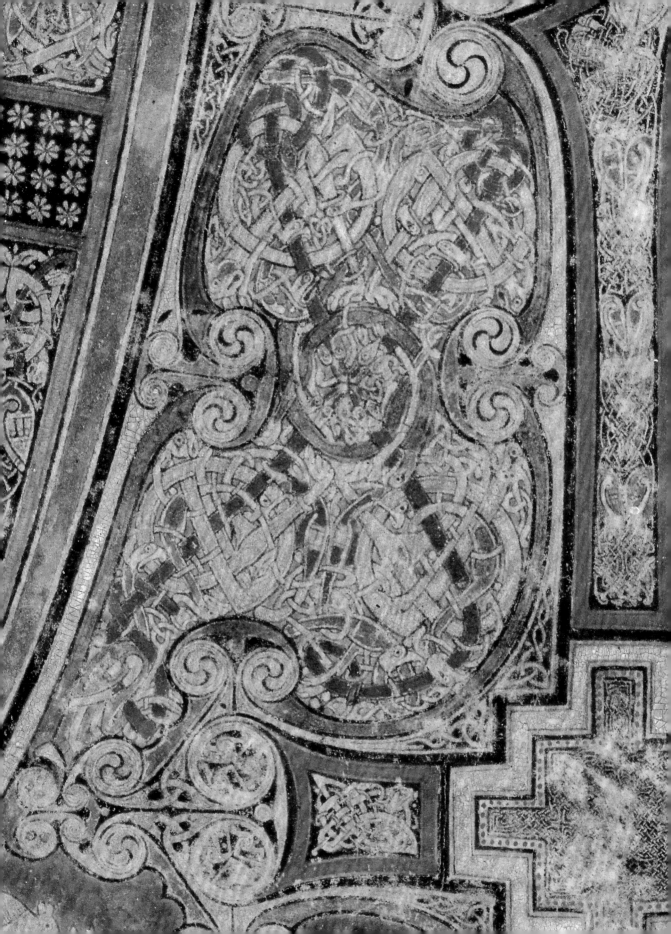

entiæ uestra pos

u est

Cu autem u

ab ecerata hi

tote quia tto prop

et u ✝

Untcquiniu

inhi montes et q

idebitis animas

en as

eritas circuitoar

rusalem auticsa

nquauit desolatio

lea sunt fugiant

inmedio eius disce

MATERIALS AND PIGMENTS

VELLUM

Cattle were the mainstay of the Irish economy. The Book of Kells was written on vellum made from calfskin. It has been calculated, though imprecisely, that 185 calves, the product of large herds, were needed for the original manuscript.[43]

To produce vellum, the skin was soaked in a bath of lime, scraped, and dried under tension on a wooden frame. Residual debris was removed using a knife in the shape of a half-moon, care being taken to avoid nicks to the skin.

The vellum of Kells is not uniform, ranging in quality, thickness and tone from ivory to dark brown. Most leaves were cut with the spine of the calf running horizontally across the middle of the opening, but, for reasons of economy, the spine runs in a vertical line down the middle of some pages. A few leaves were imperfect: the margins of ff. 185 and 246 have large holes around which the scribes fitted the text [right], while a hole on f. 316 was patched and written over.

TOOLS AND METHODS

Pages were ruled with a wooden or bone tool, guided by prickings made with a stylus or the point of a knife. Pens were made from the hardened first five flight feathers of a goose or swan. A broad nib was cut, usually held at right angles to the page, resulting in broad vertical and narrow horizontal strokes. On sections of f. 117v the nib was a little splayed, or perhaps not fully charged with ink [right, below].

An inkwell fashioned from a cow horn can be seen next to John's right foot (f. 291v) [p. 57]. Adomnán describes a clumsy visitor knocking over Colum Cille's inkwell.[44] The book held by John, bound in red and purple blind-tooled leather, may resemble the original manuscript.

Page designs were informed by constructional geometry of considerable elegance, using compasses and a straight-edge as the basic tools. Quite how the microscopic detail of some designs was achieved has not been established with certainty.[45]

Below The text of Luke 13.28–33 (teachings of Jesus on the way to Jerusalem) is fitted around a large hole in the vellum. (f. 246r)

Bottom The nib of the pen here seems to have been slightly splayed, or else not fully charged with ink. (f. 117v)

PIGMENTS AND INKS

Most of the text was written with a brownish iron-gall ink, made from crushed oak apples and sulphate of iron in a medium of gum and water. A more dramatic black carbon ink, made from lamp black or soot, was used on several pages.

The palette of organic and mineral pigments was rich, varied, and in places layered. Investigations using micro-Raman spectroscopy confirmed that the artists used orange-red from red lead (lead oxide), and yellow from orpiment (arsenic sulphide), known in the Middle Ages as *auripigmentum* (gold pigment), shining out like gold from the page. Where previously it had been believed that blues were derived from lapis lazuli, a mineral available at the time only from Afghanistan, the Raman study showed that the artists used woad (*Isatis tinctoria*), which was available locally, and confirmed that shades of a subdued green, known as *vergaut*, were made by combining orpiment and indigo. Brighter greens were made from verdigris, with a high copper content that has led to instability and the degradation of the vellum surface: the green cloak worn by Jesus on f. 255v has almost disappeared [below]. A white pigment, most noticeable on faces, was identified as the mineral gypsum.[46] Luminescence lifetime-decay measurements have identified orcein, a dye produced from lichen, as the source of purples.[47]

Right Jesus' cloak, as he rides into Jerusalem, has suffered from the instability of the copper green pigment, which has eaten through the vellum. (f. 255v)

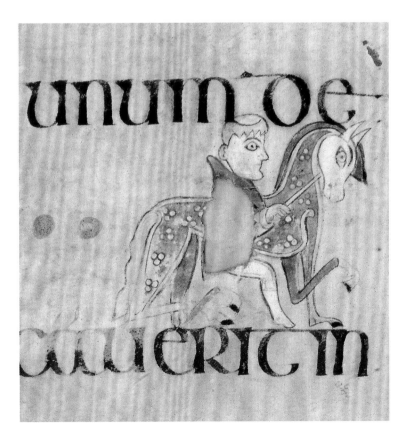

NOTES

1 Giraldus Cambrensis, *The History and Topography of Ireland* [*Topographia Hiberniae*], trans. John J. O'Meara (rev. edn Mountrath 1982), p. 84.

2 *Annals of Tigernach. The Continuation,* A.D. *1088–*A.D. *1178,* ed. Whitley Stokes, *Revue celtique* 18 (Paris 1897), p. 12.

3 *St Cuthbert Gospel*, pp. 1–3.

4 For the quire structure, see Meehan (2012), pp. 243–49.

5 Houghton (2016).

6 Farr (2007), pp. 122–25.

7 Folda (2007).

8 Clancy and Márkus (1995), p. 183.

9 John Chapman, 'The Four Prologues: Their Text and Their Meaning', in *Notes on the Early History of the Vulgate Gospels* (Oxford 1908), p. 223.

10 Ibid., p. 236.

11 Dublin, National Museum of Ireland, 06EO786: 13.

12 Henderson (2001), p. 160.

13 O'Sullivan, William, 'Manuscripts and Palaeography', in *A New History of Ireland*, vol. 1, *Prehistoric and Early Ireland*, ed. Dáibhí Ó Cróinín (Oxford 2005), pp. 511–48, at pp. 524, 528; *The Durham Gospels: Together with Fragments of a Gospel Book in Uncial: Durham Cathedral Library*, MS A.II.17, ed. C. D. Verey *et al.* (Copenhagen 1980), pp. 73, 106.

14 Francis Newton and Robert B. Babcock, 'Fragments of a Latin Gospel Book in Insular Majuscule Similar to the Script of the Book of Kells', in *An Insular Odyssey: Manuscript Culture in Early Christian Ireland and Beyond*, ed. Rachel Moss, Felicity O'Mahony and Jane Maxwell (forthcoming, Dublin 2017).

15 Clancy and Márkus (1995), p. 53.

16 New York, Morgan Library and Museum, Glazier 67.

17 St Augustine, Sermons, 261; trans. and ed. Henry Bettenson, *The Later Christian Fathers: A Selection from the Writings of the Fathers from St Cyril of Jerusalem to St Leo the Great* (Oxford 1970, 1977), p. 222.

18 Quoted by Clancy and Márkus (1995), p. 21 and n. 85.

19 Isidore (2006), pp. 160–61.

20 Adomnán (1995), pp. 14–15.

21 Werner (1994), pp. 475–81. A copy of Arculf's description survives in Vienna, Nationalbibliothek, Cod. 458, folio 4v. See Denis Meehan, ed., *Adamnan's De Locis Sanctis* (Dublin 1958), facing p. 47.

22 O'Reilly (1998), pp. 49–94.

23 *Physiologus* (2009), p. 3.

24 Ó Carragáin (1988), pp. 4–5.

25 *Physiologus* (2009), pp. 3–4.

26 Ibid., pp. 42–45.

27 Isidore (2006), p. 251.

28 Lewis (1980), p. 144.

29 Isidore (2006), p. 258.

30 City of God, xxi.4. See http://www.newadvent.org/fathers/120121.htm (accessed July 2011).

31 *Physiologus* (2009), p. 58.

32 Florence McCulloch, *Mediaeval Latin and French Bestiaries* (Chapel Hill 1962), pp. 120–22.

33 Adomnán (1995), p. 104.

34 Peter Harbison, 'Christ Praying on the Mount of Olives – Not the Arrest', *Archaeology Ireland* (Spring 2011), pp. 9–12. See also Daniel P. McCarthy, 'The Illustration and Text of the Book of Kells, folio 114r', *Studies in Iconography* 35 (2014), pp. 1–38.

35 Farr (1997); O'Reilly (1993); Ó Carragáin (1994); Farr (2011).

36 O'Reilly (1994); Farr (1997), pp. 51–103; Heather Pulliam, '"The Chalice of Devils": The Book of Kells Eucharistic Imagery Reconsidered', paper presented at the International Medieval Congress, Leeds, July 2004, unpublished.

37 Kelly (1997), pp. 102–3.

38 Henderson (2001), p. 159.

39 The earliest explicit reference to an ass in Ireland does not come until late in the 12th century: Kelly (1997), pp. 131–32.

40 Harbison (1992), figs 859–62, 864.

41 Pulliam (2006), p. 89.

42 Françoise Henry, *Irish Art in the Early Christian Period* (London 1940), pp. 144 ff.; Henry (1974), p. 212. William O'Sullivan, *The Book of Kells. An Introductory Note to a Selection of Thirty-six Colour Slides* (Dublin 1967), p. 3. J. J. G. Alexander, 'Questions of Style: The Artists', in *Kells Commentary* (1990), pp. 285–87.

43 Casey (2017).

44 Adomnán (1995), 1.25, pp. 129–30.

45 Meehan (2012), pp. 233–36; John L. Cisne, 'Stereoscopic Comparison as the Long-lost Secret to Microscopically Detailed Illumination Like the Book of Kells', *Perception* 38 (2009), pp. 1087–1103.

46 S. Bioletti, R. Leahy, J. Fields, B. Meehan and W. Blau, 'The Examination of the Book of Kells Using Micro-Raman Spectroscopy', *Journal of Raman Spectroscopy* 40/8 (2009), pp. 1043–49.

47 A. Romani, C. Clementi, C. Miliani, B. G. Brunetti, A. Sgamellotti and G. Favaro, 'Portable Equipment for Luminescence Lifetime Measurements on Surfaces', *Applied Spectroscopy* 62/12 (2008), pp. 1395–99.

SELECT BIBLIOGRAPHY

Adomnán (1995)
 Adomnán of Iona, *Life of St Columba*, ed. R. Sharpe (London 1995)
J. J. G. Alexander, *Insular Manuscripts, 6th to the 9th Century*. A Survey of Manuscripts Illuminated in the British Isles, 1 (London 1978)
Casey (2017)
 Denis Casey, 'How many cows did it take to make the Book of Kells?', in *An Insular Odyssey: Manuscript Culture in Early Christian Ireland and Beyond*, ed. Rachel Moss, Felicity O'Mahony and Jane Maxwell (forthcoming, Dublin 2017)
Clancy and Márkus (1995)
 T. O. Clancy and G Márkus, *Iona: The Earliest Poetry of a Celtic Monastery* (Edinburgh 1995)
Codices Latini Antiquiores: A Palaeographical Guide to Latin Manuscripts Prior to the Ninth Century, ed. E. A. Lowe, I–XI, Suppl. (1934–72)
Farr (1997)
 Carol Farr, *The Book of Kells: Its Function and Audience* (London 1997)
Farr (2007)
 Carol A. Farr, 'Bis Per Chorum Hinc et Inde: The "Virgin and Child with Angels" in the Book of Kells', in *Text, Image, Interpretation: Studies in Anglo-Saxon Literature and its Insular Context in Honour of Éamonn Ó Carragáin*, ed. Alastair Minnis and Jane Roberts (Turnhout 2007), pp. 117–34
Farr (2011)
 Carol Farr, 'Cosmological and Eschatological Images in the Book of Kells: Folios 32v and 114r', in *Listen, O Isles, Unto Me: Studies in Medieval Word and Image in Honour of Jennifer O'Reilly*, ed. E. Mullins and D. Scully (Cork 2011), pp. 291–301
Folda (2007)
 J. Folda, 'Crusader Artistic Interactions with the Mongols in the Thirteenth Century: Figural Imagery, Weapons, and the Çintamani Design', in *Interactions: Artistic Interchange between the Eastern and Western Worlds in the Medieval Period*, ed. C. Hourihane (Pennsylvania 2007), pp. 344–98
Harbison (1992)
 Peter Harbison, *The High Crosses of Ireland: An Iconographical and Photographic Survey* (Bonn 1992)
Harbison (1985)
 Peter Harbison, 'Three Miniatures in the Book of Kells', *Proceedings of the Royal Irish Academy*, 85 C (1985), pp. 181–94
George Henderson, *From Durrow to Kells: The Insular Gospel-books 650–800* (London 1987)
Henderson (2001)
 George Henderson, 'The Barberini Gospels as a Paradigm of Insular Art', in *Pattern and Purpose* (Oxford 2001), pp. 157–68
Henry (1974)
 Françoise Henry, *The Book of Kells: Reproductions from the Manuscript in Trinity College Dublin, with a Study of the Manuscript by Françoise Henry* (London 1974)
Isidore (2006)
 S. A. Barney, W. J. Lewis, J. A. Beach and Oliver Berghof, trans. *The Etymologies of Isidore of Seville* (Cambridge 2006)
Kells Commentary (1990)
 The Book of Kells, MS 58, Trinity College Library Dublin: Commentary, ed. Peter Fox (Faksimile Verlag Luzern 1990)
Kells Conference Proceedings (1994)
 The Book of Kells: Proceedings of a Conference at Trinity College Dublin, 6–9 September 1992, ed. Felicity O'Mahony (Dublin 1994)
Kelly (1997)
 Fergus Kelly, *Early Irish Farming: A Study Based Mainly on the Law-texts of the 7th and 8th Centuries AD* (Dublin 1997)
Lewis (1980)
 Suzanne Lewis, 'Sacred Calligraphy: The Chi Rho Page in the Book of Kells', *Traditio* 36 (1980), pp. 139–59

Paul Mayvaert, 'The Book of Kells and Iona', *The Art Bulletin*, 71 (1989), pp. 6–19
Bernard Meehan, *The Book of Kells: An Illustrated Introduction to the Manuscript in Trinity College Dublin* (London 1994)
Bernard Meehan, *The Book of Durrow: A Medieval Masterpiece at Trinity College Dublin* (Dublin, 1996)
Bernard Meehan, 'The Book of Kells and the Corbie Psalter (with a note on Harley 2788)', in *Studies in the Illustration of the Psalter*, ed. Brendan Cassidy and Rosemary Muir Wright (Stamford 2000), pp. 12–23
Meehan (2007)
 Bernard Meehan, 'Looking the Devil in the Eye: The Figure of Satan in the Book of Kells folio 202v', in *Making and Meaning in Insular Art: Proceedings of the Fifth International Conference on Insular Art Held at Trinity College Dublin, 25–28 August 2005*, ed. R. Moss (Dublin 2007), pp. 268–74
Meehan (2012)
 Bernard Meehan, *The Book of Kells* (London 2012)
Ó Carragáin (1988)
 Éamonn Ó Carragáin, 'The Meeting of St Paul and St Anthony: Visual and Literary Uses of a Eucharistic Motif', in *Keimelia: Studies in Archaeology and History in Honour of Tom Delaney*, ed. G. MacNiocaill and P. F. Wallace (Galway 1988), pp. 1–58
Ó Carragáin (1994)
 Éamonn Ó Carragáin, '"Traditio Evangeliorum" and "Sustentatio": The Relevance of Liturgical Ceremonies to the Book of Kells', in *Kells Conference Proceedings* (1994)
O'Reilly (1993)
 Jennifer O'Reilly, 'The Book of Kells, Folio 114r: A Mystery Revealed yet Concealed', in *The Age of Migrating Ideas: Early Medieval Art in Northern Britain and Ireland*, ed. R. Michael Spearman and John Higgitt (Edinburgh 1993) pp. 106–14
O'Reilly (1994)
 Jennifer O'Reilly, 'Exegesis and the Book of Kells: The Lucan Genealogies', in *Kells Conference Proceedings* (1994)
O'Reilly (1998)
 Jennifer O'Reilly, 'Patristic and Insular Traditions of the Evangelists: Exegesis and Iconography of the Four-symbols Page', in *Le Isole britanniche e Roma in età romanobarbarica*, 1, ed. A. M. L. Fadda and É. Ó. Carragáin (Rome 1998), pp. 66–94
Physiologus (2009)
 Physiologus: A Medieval Book of Nature Lore, trans. M. J. Curley (2nd edn, Chicago and London 2009)
Pulliam (2006)
 Heather Pulliam, *Word and Image in the Book of Kells* (Dublin 2006)
St Cuthbert Gospel (2015)
 The St Cuthbert Gospel: Studies on the Insular Gospel of John (British Library MS Add 89000), ed. Claire Breay and Bernard Meehan (London 2015)
Werner (1994)
 Martin Werner, 'Crucifixi, Sepulti, Suscitati: Remarks on the Decoration of the Book of Kells', in *Kells Conference Proceedings* (1994)
Martin Werner, 'Three Works on the Book of Kells', *Peritia* 11 (1997), pp. 250–326

INDEX